25 Great Walkers' Pubs in the Yorkshire Dales

GW00472063

Mike Appleton

AMBERLEY

First published 2016

Amberley Publishing
The Hill, Stroud, Gloucestershire, GL5 4EP
www.amberley-books.com

Copyright © Mike Appleton, 2016

The right of Mike Appleton to be identified as the
Author of this work has been asserted in accordance
with the Copyrights, Designs and Patents Act 1988.

ISBN 978 1 4456 5329 7 (print)
ISBN 978 1 4456 5330 3 (ebook)

British Library Cataloguing in Publication Data.
A catalogue record for this book is available from
the British Library.

Typesetting by Amberley Publishing.
Printed in Great Britain.

Contents

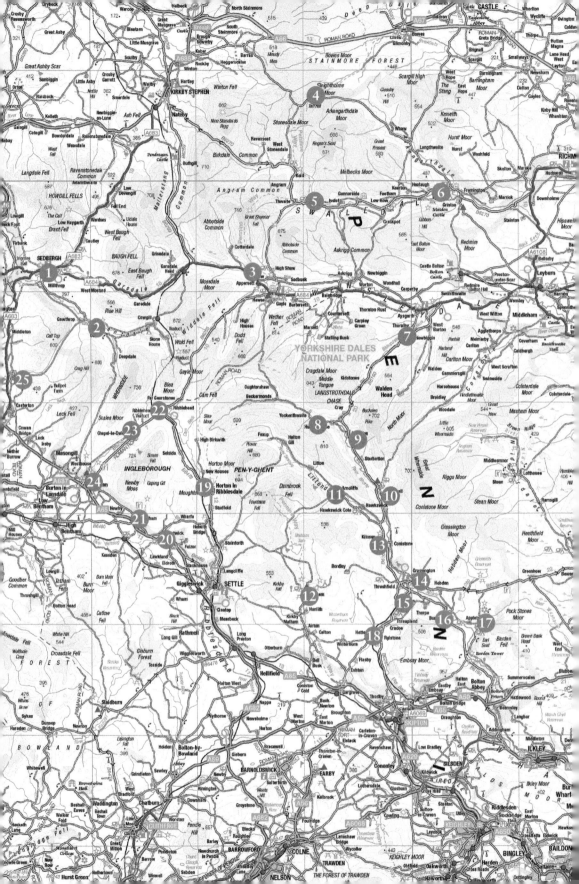

Introduction

A walk by moonlight seemed like a good idea at the time. Picking my way over the wet, slippery stones and seeing the outline of the hills above the mist that shrouded the valley was a special sight. I was alone and apart from the occasional owl and the sound of my breathing, I was lost in my own world.

Walking at night requires precision, skill and a great deal of bottle. A head torch in mist creates spectres, visions in the blackness, but it created a still and calming atmosphere for my thoughts.

I'd chosen a low level wander around the base of Pen-y-Ghent starting from Horton-in-Ribblesdale, with perhaps a quick brew midway using my Brukit. The weather however, had other ideas. Rain that started as a pleasurable spit-spot on my rucksack turned horizontal. Mist and clagg came down to meet me and obscure my path. I was more than halfway round my intended route with no option but to continue. One foot in front of the other, alone on the hill.

Eventually, I picked my way back to the village. Finding true 'black' at night is difficult anywhere in this country because of that yellow sodium streetlight glow. But with the clagg down, street lighting didn't have much effect.

However, one building stood out. The Crown Hotel. It was calling me. I opened the front door, wiped the worst of the night from my boots and walked straight into the middle of a dominos match. Tiles that were about to be placed were paused; participants looked up. I nodded, ordered a pint nervously and hoped the scrutiny would end. On the first sip I turned around and the players were back on it, intense concentration punctuated by looks up and smiles.

'Is it raining out?' one asked. 'Aye', I replied, realising I'd used a term that might have depicted me as a visitor, local or just someone trying to fit in.

'Not good that', came another comment ... and that was it.

I watched the games, saw the way various people noted they were 'knocking' and unable to make a move, then I left to head home.

The Crown Hotel was a gem to me that night and summed up why I like country pubs – particularly those in the Yorkshire Dales – so much. Coupled with a walk, they revive.

Sadly, public houses are a declining species. The British Pub Association (BPA) says there were 67,800 in 1982. In 2014, there were 51,900. 2015 saw more decline and figures of around thirteen closing per week in the latter half of 2014 and into 2015 are likely to be matched well into the future.

It is, of course, a national tragedy that pubs – once bastions of community, places where people met to share ideas, trade and devise plans – are no longer considered viable options. Many in my birth town of St Helens in Merseyside have been converted into flats. Market forces and no doubt increased taxation have meant that people buy their drinks elsewhere. Discount pubs in towns have made a difference but the availability of cheap drink in supermarkets – and, basically, other things for people to do in an evening – is probably a defining factor.

In the countryside however, some pubs are still seen as that focal point. In remote areas of the Yorkshire Dales, farmers meet up to fill in forms for subsidies and catch up on events for example. They pool their resources and help each other out. Several of the ones I visited during the course of this book were pretty full with walkers, tourists and visitors enjoying local food. The Tan Hill Inn for instance, the highest pub in England, is a refuge for walkers in winter. You can even sleep in their snow plough. Lambs will frequent the pub to keep warm.

Of course, not everything in these places is bathed in a rosy glow. Many have had to change their practices to ensure they provide something more than just a good drink while maintaining the 'feel' so they don't alienate locals. In the past I have been in pubs that just didn't like visitors. In one pub, a room where visitors congregated was called the Herdwick room – after the local breed of sheep – by regulars. But over time there has been a realisation that visitors provide an economic boost and help pay local wages. Pubs also boost local economies by an average of £80,000 per year and around eighty per cent of these are community or rural pubs.

Micro-breweries have become more popular as well. The George & Dragon in Dent is the tap house for the Dent Brewery and is a must visit. The number of breweries in the UK totals more than 1,400; beer and pubs contribute £22 billion to UK GDP and generate £13 billion in tax revenue. Nearly a million people are employed in the industry, according to the BPA and almost one billion pub meals are sold annually.

That night in The Crown Hotel – and the several nights that preceded and followed – encouraged me to seek out the top boozers the Yorkshire Dales. Choosing twenty-five of what I considered to be the best was a hard job ... well, someone had to do it. I met locals, landlords and real characters. I was told stories of ghosts, snow drifts, shootouts and quirks. To get on my list they had to be walker friendly; but that's not a surprise in an area famed for its countryside. They also had to have character and, naturally, a damn good walk nearby. They also needed to be able to tolerate a very wet and muddy author following said rambles.

I used many of the pubs from my own travels in the Dales over the last three decades. Several were very familiar. The Wheatsheaf in Ingleton has been the end point of many a walk and caving trip. The George & Dragon in Dent stems from my time as a child in the village hearing my dad sneak out of our friend's cottage while I pretended

to be asleep. Others came as recommendations such as the Fountaine in Linton and The Farmers Arms in Muker, and several were just the result of when preparation meets opportunity – serendipity.

Mike Appleton, May 2016.

A Note

To aid visiting the pubs and walks, and so they are displayed clearly, they start in the north-west of the Yorkshire Dales National Park and then move to the north-east, south-east and south-west. A couple are just outside the boundary of the Park, but are true Dales pubs.

The walks are detailed as a panel in each description. The author has purposely not gone into vast detail on each as the assumption is that walkers and visitors to the area will carry a map. All distances are approximate.

The best maps to explore this area are Ordnance Survey: Southern and Western (OL2), Northern and Central (OL30), and Howgill Fells and Upper Eden Valley (OL19).

1. The Dalesman Country Inn, Sedbergh

Sedbergh is one of the most historic towns in the Yorkshire Dales and a real honeypot for those who like their hills grandiose and their views breathtaking.

The town, which is on the Dales Way, nestles at the foot of the Howgills and a great route from its centre takes you to two of the area's real gems. Cautley Spout is England's highest above-ground cascading waterfall, as Cautley Holme Beck travels some 200 metres down the fells, while The Calf offers panoramic views of the surrounding mountains but also the Lakes, Eden Valley and North Pennines.

Down on the high street itself, it's easy to be distracted but that's no bad thing following a long meander. Known as England's Book Town – established to attract visitors following the foot-and-mouth crisis of 2001 – it has several bookshops, some of which cater for very specific tastes. Sedbergh isn't lacking in heritage either, as it was granted market town status by Henry III in 1251. It has a church that dates from the twelfth century, the remains of a castle believed to be from Saxon times and also several old houses and buildings – one of which dates back to the fourteenth century. In the past it would have been a fairly isolating place too. When you're on the high

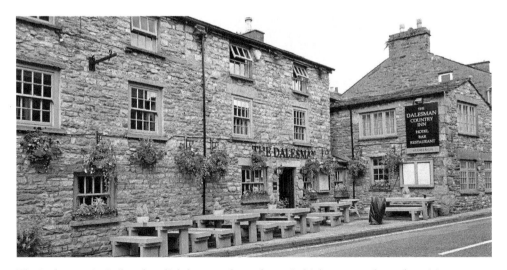

The Dalesman in Sedbergh – slightly away from the main high street and worth a visit.

street, the hills rise up behind those dwellings and those living in these remote places would have faced a long and tough trek into the town.

For more modern walkers, there's a plethora of pubs too. The Bull Hotel is right in the heart of the high street and dates back to the seventeenth century, while The Red Lion's history dates back to the 1800s. But it was the Dalesman – The Dalesman County Inn to be precise – I was most attracted to. With the church on your left, if you follow the road and keep your eyes dead ahead of you, you'll miss it. Twist your focus to the right and tucked away is a country pub in every sense of the word.

It's more modern than its counterparts as it is clear it has undergone some renovation compared to the other historical pubs in the town, but that shouldn't distract from its obvious charms. Formerly the Golden Lion, it has gone through some radical transformation over the last twenty-five years to bring it up to modern expectations. The owners have taken much of the original atmosphere of that pub and enhanced it. Stone walls feature throughout; lighting is set to make it homely but not too bright, as that would detract from the cottage feel. Plus, it has a reputation for serving good ale. As the town's only free house it can offer a number of different cask ales and not be tied to any particular brewery. You can still get a pint of Timothy Taylor and Black Sheep, though, and on a hot day take a seat outside and watch the world go by.

Like many country pubs, focus has been placed on good food – it is locally sourced too. Lamb comes from Hebblethwaite, just 2 miles away and they make their own ice cream, fudge, toffee and biscuits. But the spotlight on food doesn't take away the

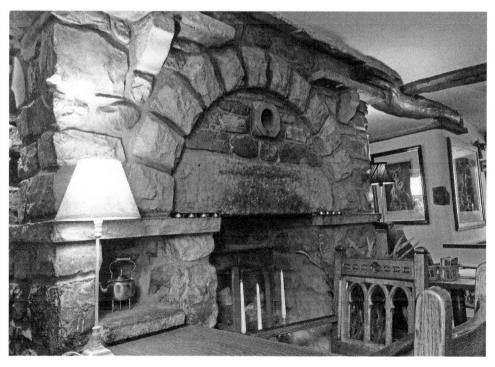

Beautiful stone fireplace in keeping with the rest of the pub.

Little nooks and crannies add to the character.

feeling that a few beers here would lead to great tales and a great evening. Walkers sharing stories wouldn't be disturbing the diners!

I sat near the fireplace on my visit, on a seat that runs along the main wall. To my left were several candles in bottles while ahead of me was the glow of the bar. Families were dining too but the inn was quiet, homely and a haven. A must visit.

The Pub

Address: The Dalesman Country Inn, Main Street, Sedbergh, Cumbria, LA10 5BN.
Website: www.thedalesman.co.uk

The Walk

Start Point: The Dalesman.
Destination: Cautley Spout.
Distance: Around 5.5 miles to the Spout.
The Route: Walk towards the National Park's car park, go past it and take the second path on the left (SC660921) towards Underbank (SD667925). From there follow the path to Stone Hall and then through to Ellerthwaithe. This soon becomes a wonderful meandering green lane with the River Rawthey on your right and, further along, are beautiful, if somewhat brief, waterfalls. Following this route will eventually bring you to Cautley Holme Beck (SD692967). Turn left and walk to the Spout itself. It is England's highest cascading waterfall above ground, and the Beck travels some 200 metres down the fells to create a view more than worth the effort it takes to walk to its base. To return, follow the steep path on the right-hand side to the top and thus towards The Calf (SD667970) and descend via the Dales High Way to Sedbergh, or turn around at the base of the Spout and retrace your steps.

2. The George & Dragon Hotel, Dent

Walk through Dent and you're transported back to the Dales and how country life used to be.

The small village, with its cobbled narrow streets and the smell of coal and wood fires, gives a reflection on what remote Yorkshire Dales life would have been like many years ago. It's this charm that makes it a very popular destination for visitors and walkers. It sits on the Dales Way and is within walking distance of Whernside … well, it is for those who like 20-mile adventures.

More importantly, it has a great pub in the George & Dragon. Much of my 'Dalean' life has focused around this pub, situated between two roads in the middle of the village. As a child I would visit Dent with my father, whose friend owned Ivy Cottage

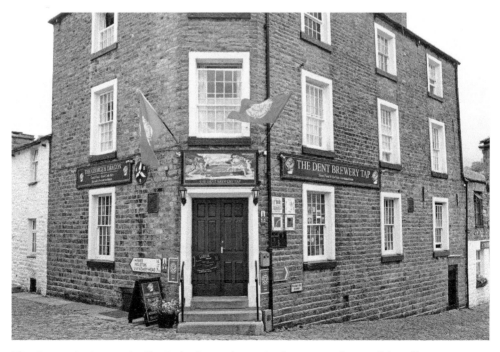

The George & Dragon is effectively the marker point for two roads out of the village.

at the back of the Dragon. As I went to bed in an evening, tired from walking up Flintergill – a gorge nearby – or walking the River Dee, he would sneak out the front door with his mate John and have a few beers in the pub. I would wake the next morning none the wiser, only realising in my later years what had caused my dad's thick head: the local brew in the George.

The pub has undergone some renovation since those days in the late 1980s. Originally, it had a long bar, but the pub is now split in two with a much shorter one on either side. They have also turned some 90 degrees! One room has a roaring fire and easy access to the pool table while the other is a lot more sedate and better for visitors who want something to eat. A lower restaurant area exists too.

Local ale is still the key though and the main reason the pub is an important stop on a walker's trip. The Grade II-listed George is the taphouse for the Dent Brewery and source of many a hangover over the last few years! It is brewed just up the road in Cowgill and is internationally recognised. Originally, the idea was for the staple Dent beer to be sold at the Sun Inn in Dent, but as word spread so did demand and the brewery was at capacity. Now, it makes around six real ales – including my favourite, the blonde Golden Fleece. Ramsbottom is good too as is Kamikaze. The latter is exactly how it sounds. Say goodbye to any feeling in your body if you drink more than four!

Originally, the pub stands on the site of Dent's marketplace where a market cross and stocks would have been situated. It has a distinctive V-shape because it is at an intersection of two roads. It began life as a mill building, some two-storeys high, but a third tier was added in the early 1800s. The beer was brewed in a local shop opposite with the water

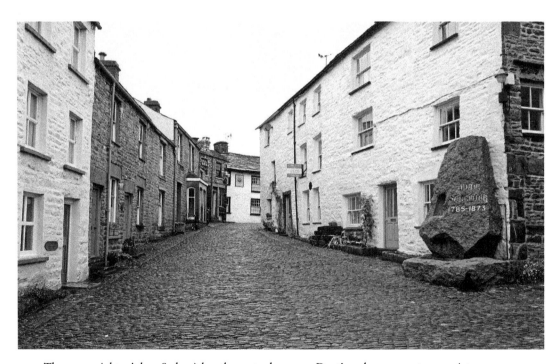

The memorial to Adam Sedgwick – the water here was Dent's only source at one point.

A lone walker up Flintergill.

taken from a fountain, which was the village's only source at one time. That fountain is now a memorial to Adam Sedgwick, one of the founders of modern geology.

In 2006, Dent Brewery bought the George and that has proved to be a critical moment in the history of both businesses. Visitors come to the George to sample the fine ale and in turn, the sales of the brewery's bottled beer have increased. Booths the supermarket and other outlets stock it too. The pub has also won a stack of awards, including CAMRA Westmorland Pub of the Year in 2014.

It would be unfair not to mention the other great pub in Dent too – The Sun Inn. With its sun decal on whitewashed stone walls and steps that would have allowed people to mount their horses, this is a feature led pub.

It's been in Dent for more than 300 years and doesn't have what you would call 'modern trappings'. There's no TV or 'bandits', just the clamour of locals and their dogs, an open fire, original coin-studded beams and some great beer. Like the George, that beer is locally brewed with Tiffin Gold (3.6 per cent), Ruskins (3.9 per cent) and Monumental (4.5 per cent), being made just over the fell at Kirkby Lonsdale brewery.

The Pub

Address: The George & Dragon, Main Street, Dent, Near Sedbergh, Cumbria LA10 5QL.
Website: www.thegeorgeanddragondent.co.uk

The Walk

Start Point: The George & Dragon.
Destination: Flintergill.
Distance: Approximately 6.5 miles.
The Route: Facing the pub, follow the road right until you reach a small opening before a walled stream, then turn right. Follow this road up past the playground and turn left. This road eventually becomes rockier and takes you up Flintergill. The gill itself is on your left and can be scrambled up in dry conditions. It is very entertaining! On the right, midway up the path, is an Old Barn which can be entered – it's part of Dent's heritage walk. Again, when you reach the top of Flintergill there is a short walk to a view point. From there, head back to the stream and follow it up to the junction with Green Lane (SD698858). Turn right and follow this down to the road. On a clear day the valley on your right is a superb view. Once you hit the road, turn right until you hit a path on the left (SD683864). From here, you are charting a route back to the River Dee and the Dales Way. Head to Tofts (SD682878), then at (SD684879) take the path on the left to Dillicar. Here, either walk through to Dillicar or take the road to (SD681885) and go across the field to join the Dales Way. Turn right here and walk back to Dent. At Church Bridge follow the obvious road back to the village and the George.

3. Green Dragon, Hardraw

Many pubs have their own particular quirks and features but none more so than at the Green Dragon in Hardraw.

The inn itself dates back to the thirteenth century and retains many features from that era, but it's what lies behind that makes this place all the more unique. By entering the inn, turning right and paying a small fee, you can visit one of the Yorkshire Dales' real gems. Around 500 metres up the path is the Hardraw Force, the highest single drop waterfall in England.

Water flows over the Hardraw Scaur formation some 100 feet, unbroken, into an amphitheatre of sound. It passes carboniferous limestone, sandstone and then shale before plunging into a large pool. Getting closer to the Force you can see this geology in the strata that has developed over millions of years and, on a dry day, you can walk right up to it. The ravine that houses this impressive sight is also a sight for sore eyes too – ancient woodland with many species of birds and wild flowers.

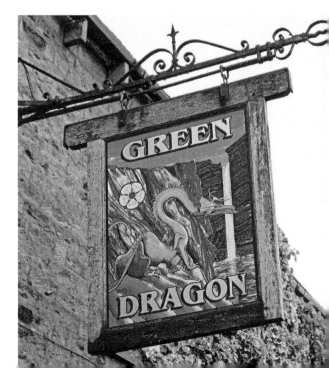

Distinctive hanging sign, an example of fine artistry.

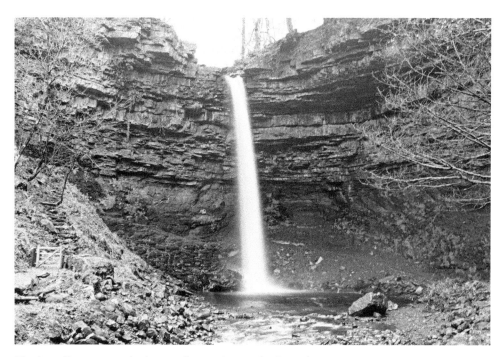

Hardraw Force – not a bad water feature in your back garden.

The Green Dragon makes the best of this stunning feature by holding annual brass band concerts a little further back up the path. They effectively use the bowl of the waterfall and Scaur as a concert hall providing some amazing acoustics. The pub itself also hosts regular folk festivals and music events, all of which attract visitors from all over the world.

'Hardraw' comes from the old English for 'shepherd's dwelling' and the land was once owned by Cistercian monks who kept a grange in the village. The early Northern (Yorkist) Kings would rally their troops at known locations such as 'at the banner of the Green Dragon' near the waterfall. It is possible this is the origin of the inn's name – the pub's sign does indeed show a green dragon and white rose.

The public bar area dates to the fourteenth century and in keeping with the historical nature of the entire site, has been restored superbly by D. Mark Thompson. His name is depicted boldly on the front of the pub as licensee – much in the same way previous incumbents of the role would have displayed in the late 1800s. That name will soon be replaced by another as Mark and his partner Yvonne have now semi-retired. As well as the bold swinging sign there is another one that says 'Hippies. Use Back Door. No Exceptions'. Thankfully, this isn't extended to walkers who are more than welcome and as the village is on the Pennine Way there are plenty of those!

Inside, the inn has flagged floors, open fires, beamed ceilings and stone walls. In winter it is somewhat dark, but the fire illuminates faces, creating a unique homely quality. You could say it is a little ghostly at those times and indeed, there are tales of paranormal activity in and around the pub! A priest's hiding hole was reportedly found in the 1970s above the former bar/kitchen area. It apparently led underground to the graveyard next door. Sadly, it was destroyed and filled in.

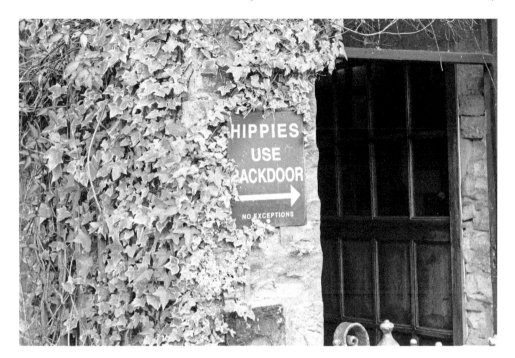

Round the back if you lean to the left!

On 12 July 1899 the pub suffered serious damage when floods tore through the village, taking coffins and gravestones some 2 miles down the valley. A large tree went through the wall and the flood also took out the rear and front doors and windows, as well as furniture and most of the cellar's contents. Apparently, the taproom still bears this high water mark.

The Pub

Address: Green Dragon, Hardraw, Hawes, Leyburn, North Yorkshire, DL8 3LZ.
Website: www.greendragonhardraw.com

The Walk

Start Point: Green Dragon.
Destination: Hardraw Force.
Distance: Approximately 1 mile.
The Route: A route description isn't needed. From the public house pay your ticket and follow the obvious path up to Hardraw Force. On dry days it is possible to go behind the waterfall but it isn't recommended as it can be very slippery and dangerous. The waterfall is open daily (10.00 a.m. in winter and 8.00 a.m. in summer) until dusk. Entry is £2.50 per adult and £1.50 per child with under-fives free. A group ticket for two adults and two children is £7.50.

4. Tan Hill Inn, near Reeth

It seemed like a good idea at the time. The mission was to leave Lancashire in the evening, detour at Ingleton and then drive to the highest pub in England for a night of research followed by an open air bivvy. It turned out to be a genius plan too – but it went a little too well for our heads the next morning!

Tan Hill Inn is pretty well known and famous across the globe. Its marketing strapline is 'the world famous'; not only because it is the highest pub in England at 1,732 feet (528 metres) above sea level but its folklore about punters being locked in for weeks when the snow descends is legendary. The old adage of what could be worse than being snowed in at a pub for weeks on end...

Tales abound of lambs wandering around the inn when the weather is unpleasant outside and it has been visited by a fair few celebrities over the years. Music acts line

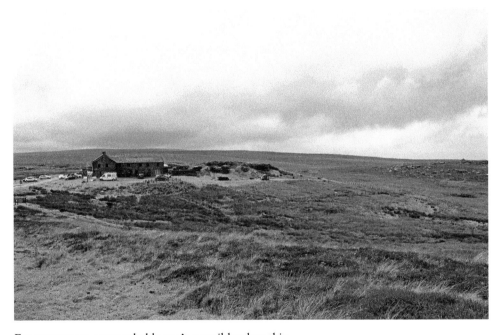

For remoteness, you probably can't get wilder than this.

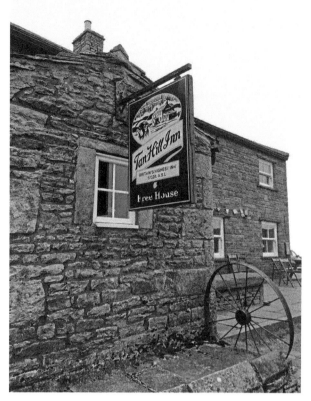

Right: The pub makes the best of its uniqueness at being the highest in England.

Below: ...at 1,732 feet above sea level.

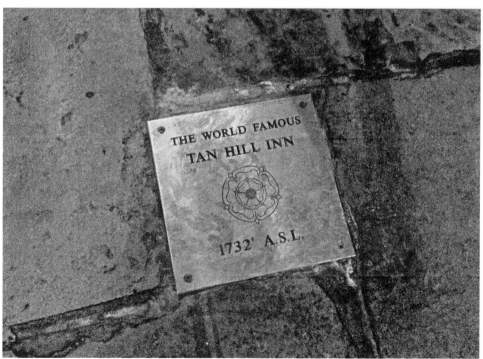

up to play there too and thus create a little bit of history each time by marketing it as the highest gig in the highest pub in England!

It is also on the Pennine Way, and the sight of it, lights on, smoke coming from the chimney must be a welcome site for those tabbing that long route – especially after a few hours on one of the most remote sections of the 267 mile walk.

The Tan Hill Inn dates back to the seventeenth century, and during the next 100 years was used as a hostel by workers digging coal pits. Coal in this area was produced around 1384 when shallow shafts and seams provided it for Richmond Castle. The product itself was dirty and dusty but local households mixed it with peat so it could be revived in the morning. The last mine at Tan Hill closed in 1929 but the pub had built up enough custom to keep on going – even after the nearby miners' cottages were demolished.

Since then the pub remains a focal point for locals in the area but has also become a real tourist destination. It plays on the fact that it is remote and therefore quirky, but doesn't shirk what a pub should do, which is serve good food and good beer. Its fire has never gone out in more than 100 years and the porch is left open at all times, so if walkers or visitors need shelter, they can have it. New landlords Viv and Steve Bailey were also in the process of letting people sleep in the snowplough when it isn't needed. It has mattresses in the back for what would probably be a cosy, if a little noisy, night's sleep.

The pub has a traditional stone floor in the main bar area, with the fire at the right-hand side. There is a room to the right that is a 'snug' and one to the left with larger tables – ideal for groups of people. The first few beers on my evening flowed well in this room before Johnny Hartnell and I moved into the bar. Here, we got chatting to Steve and Viv, as well as the barman, and tried out another of the local ales, called My Generation. It went down well – a little too well. Steve told us that they had lots of experience of the other side of the bar and wanted to take that customer service standpoint forward and, more importantly, be part of a community at the Tan Hill Inn.

They had taken over as landlords of the pub on 1 March 2015 and two days later were snowed in. It was what you would class as a real baptism of fire – with the four punters who were equally as marooned. Of course, it wasn't something unexpected – in 2009 a similar event on New Year's Eve saw people unable to leave for three days – but perhaps Steve and Viv's experience came a little earlier than planned or than they might have liked. They'd only recently been back in the country after spending the best part of four years travelling around the world; Steve had been a head teacher, with Viv running a charity.

They explained that Scouting for Girls were due to host a concert at the inn for *Children in Need* at the back end of 2015, Elle Harrison had sung Ring of Fire there earlier in the year for BBC's *Countryfile* and Richard Hammond had filmed *Top Gear* at the pub in February. The pub has long been a magnet for film and programme makers wanting a remote and unique location. Ted Moult and his famous double-glazing Everest ads were filmed there the 1980s while James May and Oz Clarke visited in 2009.

As proprietors of the inn they couldn't have done more to make us feel welcome and to be honest this news might be a little bit of a shock for those who visited the inn in the past! In 2012, *The Guardian* reported that landlady Tracy Daly had been described

The fire hasn't gone out in 100 years.

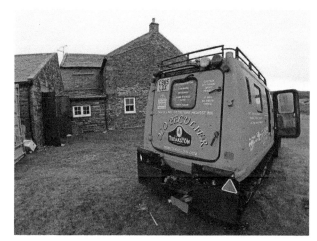

Feel free to spend the night in this!

Or you could sleep outside...

as the rudest person in Britain! She was a kind-hearted person apparently, but a little sharp-tongued for some visitors who didn't get her rapier-like wit. Neil Hanson and his wife were landlords for a short time in the '70s and Neil has written two cracking books on the pub called *Inn at the Top* and *Pigs Might Fly*.

The barman continued to refuel our glasses and, seeing we were suitably relaxed, began to spin some tales about ghosts and ghouls. History claims that the dining room was used as a makeshift mortuary for local mining facilities and, surely with that in mind, he told us glasses would fall off the bar with no one in sight. Floorboards would creak upstairs too and you'd often hear footsteps when no one was up there. It made me smile of course; all older pubs seem to have these tales, but it was difficult to come up with a suitable explanation as to why pint glasses would propel themselves to a smashing end without some kind of paranormal reasoning. What was scarier though, was a jar of old mobile phones, pickled, on the window sill. A previous landlord didn't like people talking probably!

As the night transitioned into the wee small hours it was clear we'd have to make a move. Several drunken attempts at 'ring o bull' hadn't gone according to plan and it was time to go. The game involves simply swinging a ring on the end of a rope so it hooks onto a fixing at the top of a door frame. The idea is to do it in one swing; perfectly judging the speed to land on top of the hook. Anyone coming through the frame at the time of the swing though would surely end up with a dint in their head ... but the only damage we did was to the frame, ceiling, ourselves and our pride, let alone the hook.

Perfect.

We bade farewell, grabbed our bivvying gear from out of the car and set up camp at the right-hand side of the inn – with great views of a starry sky. Next morning we were awoken by ducks and grouse calls and the distant rumble of the A66. Headaches well and truly thumping we stumbled back to the pub and enjoyed a breakfast.

A truly superb evening in a truly superb pub.

The Pub

Address: Tan Hill Inn, Reeth, Richmond, Swaledale, North Yorkshire Dales, DL11 6ED.
Website: www.tanhillinn.com

The Walk

Start Point: Tan Hill Inn.
Destination: Keld, Ravenseat circular.
Distance: Approximately 9.5 miles.
The Route: Thank you to the Tan Hill Inn for the inspiration behind this superb walk! From the Tan Hill Inn, turn right and take the first turning left. Follow the road until you reach a footpath sign on the right. This path will be your friend for the majority of the journey. Keep following the path until you cross Stonesdale Beck at NY885055. Head up the hillside, there is a deep gully to your right. Follow this path until you reach a ford and Ravenseat. From here, the path continues and the river is on your right below. Where the path forks, keep right and follow it down through Lamb Paddock Scar, Brian Cave and Cotterby Scar. When you reach Silverhill, cross the road (NY886015) and head for Currack Force. Keep following this path down to Catrake Force (approx SD895013) and then head up the Pennine Way back to the Tan Hill.

5. The Farmers Arms, Muker

'Remember when pubs used to be real pubs? Places where people would go to unwind and socialise with friends, drink good beer and eat hearty wholesome food...'

The marketing from The Farmers Arms in Muker couldn't ring more true. This is a gem of pub in a beautiful Dales village. Darren and Emily Abbey took over in 2010 and have made it a real destination for Dales walkers, while maintaining its history and

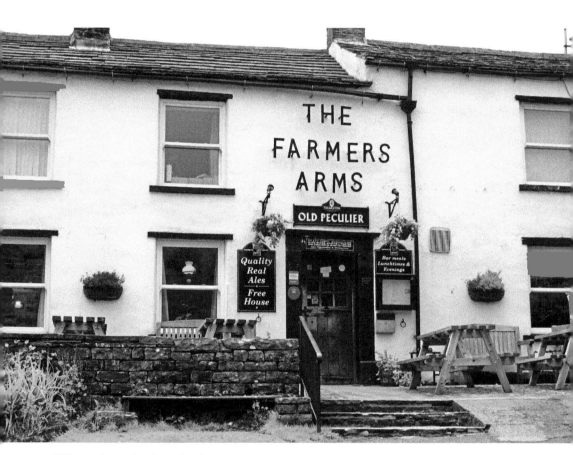

When pubs used to be real pubs...

atmosphere. They incorporated the walk from Keld, over Kisdon Hill to the pub on their wedding day in 2008, well before they had the opportunity to take ownership. It's clear The Farmers Arms it is a real labour of love for the couple, as is their promotion of Swaledale. On the pub's website there is detailed information on the history of the area as well as several suggested walks. It is also on the Pennine Way.

The pub itself is a free house and very popular with locals. It has a traditional open fire, but not one built to look rustic that is actually new when you get nice and close up! It retains the charm with a stone-flagged floor and for me the best place to have a beer is in the snug. It is small, but has that traditional floor and beams on the ceiling. The landlords are keen to avoid the trappings of modern life and this part of the pub is the best place to do that. They aren't fans of laptops and mobile phones as, according to the pub's website, 'they all detract from the traditional pub atmosphere and the art of conversation.'

Muker in Old Norse means 'the narrow newly cultivated field' and it will be clear if you follow the walk below, why that is apt. The Norse settled here as it is near the River Swale – a perfect spot to establish crop growing. Originally, it had a chapel of ease in 1580 (restored in 1891) which was rebuilt and a graveyard consecrated. The tower, nave and chancel all date from this period. The vicarage was built in 1680 and is now the village shop.

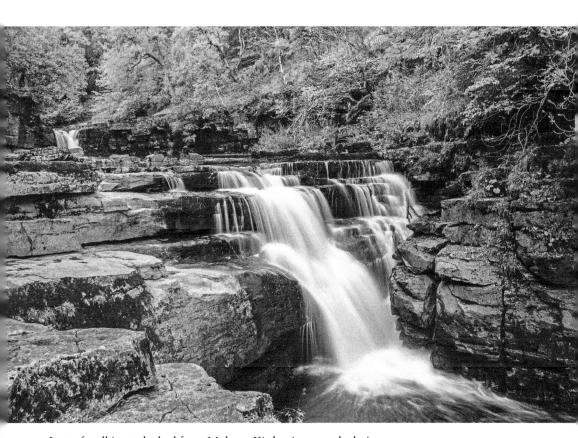

Lots of walking to be had from Muker – Kisdon is a superb choice.

At the time of writing, Darren and Emily were looking to move on from the pub to try different things in their lives even though it is a profitable business. They've said, 'This pub is more successful and profitable than ever, but we feel the time is right to hand the baton of ownership to someone else, someone hopefully as much in love with the pub and Swaledale as we are, who will continue with its success, and uphold the local traditions.' Amen to that.

The Pub

Address: The Farmers Arms, Muker, Richmond, North Yorkshire, DL11 6QG.
Website: www.farmersarmsmuker.co.uk

The Walk

Start Point: The Farmers Arms.
Destination: Kisdon Force circular.
Distance: Approximately 6 miles.
The Route: There are several routes to Kisdon Force but this is surely one of the best; following the Swale up one side and then coming back down the other. Turn left out of The Farmers Arms and walk up the small hill that is above the road. Here, you are striking to find the second of two paths that take you to the same place (SD910979). Don't worry if you take the 'higher' path/route, you will eventually reach the same destination. The lower route takes you through pasture and is stone flagged through fields and meadows. When you reach the river, turn left (SD909986) – note the bridge on your right – and follow this route until you reach Birk Hill. There is a small gap in the right-hand side wall to chart a route down to the force, but it is very steep. The alternative is to walk a little further up the route to NY896008 and follow the path down. There is a hand rope down to the river here and the rocks around the falls themselves are very slippery. Returning, take the path to Keld but instead of heading into the village cut right down to the river, across the footbridge, and take the path to the right. This follows the Swale back to Muker. Remember the bridge you saw on the outward journey? Cross it and you'll be back on that stone path to the village.

6. The Black Bull, Reeth

Classed as the unofficial capital of Swaledale, Reeth is a charming village north-east of the Dales. It is located in the Yorkshire Dales National Park at the point where the tranquil and picturesque Arkengarthdale meets Swaledale, which has been carved by the river bearing its name.

As well being a market centre for the local community, it was, in the past anyway, a real hub for knitting and lead. Nowadays, as well as being home to the Swaledale Museum, which has some fantastic displays on local life and archaeology and cafés that sell local produce, it has three great pubs.

The Black Bull dates from 1680 and is the village's oldest pub. You'll notice it because the sign above the front entrance is upside down in an apparent two-fingered salute to

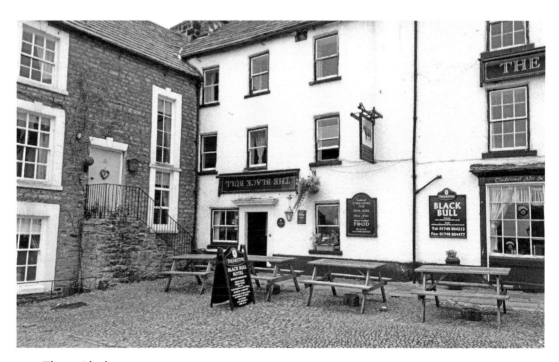

The upside-down protest.

National Park officials. Previous landlord Bob Sykes attempted to tidy up the exterior of the pub by removing its render to expose the original 250-year-old walls and to comply with English Tourist Board accommodation grading requirements. He was also worried about it being a danger to the public because the existing facia was crumbling so much.

The Park felt differently, though, and threatened legal action if it wasn't replaced. They said it would have had some kind of render years ago and wanted it to be keeping with the original format. Upset at this, someone local turned the sign upside down in protest at the attitude of park officials – and although it has moved from its original spot, it is still that way round.

The Black Bull won't be to everyone's tastes but is a true local pub. It sells the superb Theakstons and Black Sheep you'd expect from a Dales pub, but there are plenty of other drinks on offer. The atmosphere is what makes this a great pub. During the day, you can while away the hours after a long walk but in the evening those feet will be tapping, as the pub hosts many local bands and entertainment.

Next door to the Bull is the Kings Arms and that is also well worth a visit. It's a little more clinical than its neighbour but does superb food. It was originally built in 1734 and is named the 'Middle House' by locals because of its position overlooking the village green.

Just up the road is The Buck – a Coaching Inn dating back to around 1760. It is at the point where a toll was once charged to passing travellers. It has many good features such as beams and, when I visited anyway, a superb organic cider promotion!

Incidentally, next to Reeth is Grinton and walkers can follow the ancient 'Corpse Way', according to the Black Bull's website. This runs from Grinton to Keld, at the head of the Dale. It reads, 'Because this was the only consecrated ground at the time, the dead were carried here in wicker baskets along an ancient track.' Each to their own!

Where two Dales meet...

The Pub

Address: The Black Bull, High Lane, Reeth, Swaledale, North Yorkshire.
Website: www.theblackbullreeth.co.uk

The Walk

Start Point: The Black Bull.
Destination: Wander down the Swale.
Distance: Approximately 4.5 miles.
The Route: From the Black Bull, walk down the village until you reach Reeth Village Stores. Opposite it is the route to Back Lane. Go straight on this road and before it turns left you will see a stile. Note it! Turn left and follow the track to the end and cross the stile. From here, follow the obvious path until you reach a large footbridge over the Swale on your left (SE031989). Cross it, take the path forward and then take the path on your right towards the Swale. Follow this beautiful route until you reach the road. Turn right and at the Scabba-Wath Bridge turn right, then right again to reach the B6270. Go right and follow the road until you reach an obvious path on the right-hand side (SE012985). This takes you back to Reeth hugging the other side of the Swale. At SE028990 you have the option of striking across fields back to the stile you noted, or you can follow the river around to the head of the footbridge and retrace your steps.

7. The George Inn, Thoralby

Thoralby is one of the least well-known villages in the Dales. Off the beaten track, it is picturesque, 'quaint' and almost living in its own bubble away from the busier Aysgarth just over a mile away. At its hub is The George Inn, a cosy welcoming pub built in 1732. It is owned by Charles and Becci Martin and has plenty of character, from the large original fireplace and panelled walls to art and ornaments from around the world. It offers four-star en-suite accommodation and Cask Marque Accredited ales.

There were originally three pubs in the village which derives its name from Thoralds Farm when the area was settled by Vikings. In the Domesday Book it is referred to as Turoldesbi.

One of the pubs is now the post office and store and the other was the eastern part of a house on the north side of the green. That pub was known as the Loyal Dales Volunteers. The George is the only one that remains and is a Grade II-listed building.

The village had a chantry chapel of All Hallows founded in the fourteenth century by Lady Mary Neville. Although no physical trace remains, the name is commemorated on a row of cottages called Chapel Close and a house called Chapel Garth. Monks are known to be buried in the adjoining garth of paddock. Nearby is a fifteenth-century

Built in 1732 and immaculate.

pinfold, which dates from the times when most of the land was common. Stray animals were penned up and released only after their owner paid a fine to the lord of the manor.

Much like its village neighbours, lead and iron ore were minded here until the 1800s.

The Pub

Address: The George Inn, Thoralby, Leyburn, DL8 3SU.
Website: www.thegeorgeinnthoralby.com

The Walk

Start Point: The George Inn.
Destination: Aysgarth Falls.
Distance: Linear, approximately 2.5 miles.
The Route: This is a linear route from the pub to the spectacular falls. Turn right out of The George and walk on the road until you come to a significant track on your right-hand side (SD998867). If you have gone to Old Hall Farm you have gone too far. Take the track until it throws a significant right and before it turns left, take the path to Keld Gill (SD995868). Follow it for a short distance before turning right and heading towards Folly Lane (SD994873). This track is straight until it opens out. Go right and then follow it down to the road. Turn right on the road into Aysgarth. From the village there are several routes to the falls. The most direct route, sadly, is to follow the road until you find the church. There, a route takes you off the main A684 road to the falls (SE004884). This cuts a nice path until you reach a road. Turn left and follow the road down a few metres to a great viewing point of the upper falls. There are plenty of routes, well signposted to view the falls closer, as are the paths to the middle and lower falls.

Aysgarth upper falls.

8. The George Inn, Hubberholme

'We have been here since June 2013,' Ed Yarrow tells me. He went on to say: 'One of the reasons we could finally get a pub in the Yorkshire Dales was because our lad Jack was going to University. We lived in Leeds at the time and previously couldn't move an 18-year-old lad from the middle of the city to the middle of nowhere. So when he decided to find his own way, we gave it a shot.

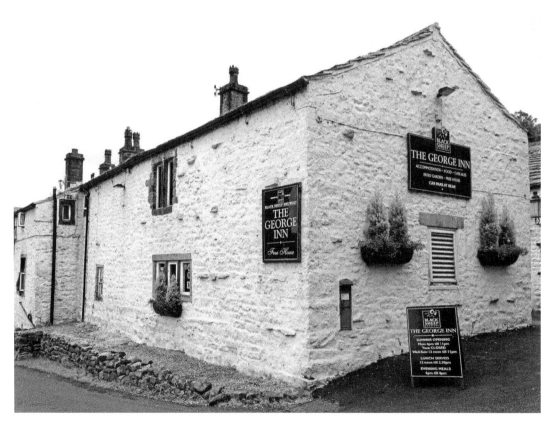

Seventeenth-century George at Hubberholme.

Display of serving jugs.

Snug room to the left of the small bar.

Ed and his wife Jackie are owners of the Grade II George Inn at Hubberholme, a seventeenth century pub in one of the quieter parts of the Dales. We're in the bar on a summer's day. Ed continued:

> My lad wasn't best pleased when we told him though. When he went back to Uni he told his girlfriend Frankie, who is from Bedford, that we'd gone mad. He said we'd packed our jobs in and sold his birth right from under him to buy a pub in the Dales. Frankie asked him if it was the 'candle pub' and he said yes. It turns out she had been coming here from the age of one with her family. We went from persona non grata to the coolest parents in the world! That sealed our fate really.

The George is in Hubberholme, just off the B6160 near Buckden. The village has the pub and a church, with the River Wharfe splitting them down the middle. The pub, on the left-hand side, is known as the candle pub … or at least the pub that has a candle lit to signify it is open.

> It was built in 1630 as a farmstead and became a pub in 1754. Before that it was a vicarage and when the vicar was home he would put a lit candle in the window to tell his parishioners they could call in. When it became a pub, that tradition and custom continued and therefore a lot of people called it the candle pub.
>
> It was owned by the church until 1965 and we came here in 2013. It had a grim reputation because the previous landlord was, by all accounts, a bit grumpy. He didn't open when he said he would and at times wasn't very nice to people.
>
> When we decided we wanted to move out of Leeds and look for a business we had some set criteria. It had to be a pub, a B&B, be 'rural' and in Yorkshire. That gave us the Dales, the Moors and North Yorkshire to go at, but a friend of ours spotted the George was up for sale and said we should take a look. And here we are.

It's easy to see why Ed and Jackie were attracted to Hubberholme. It's a beautiful part of the world and the pub is very well known. Prolific writer and playwright J. B. Priestley frequented the village and called it the 'pleasantest place in the world'. 'You can see why it is supposed to be the second most photographed and painted pub in the country,' Ed continued:

> Apparently somewhere in the Cotswolds is the first. We'd only been here a few days when we had a guy here celebrating his 60th birthday. He was a dentist from Leeds and had had a picture of the pub in his surgery for twenty-five years. He had to celebrate his birthday here.

The pub has been upgraded over the years. The original part was extended in the eighteenth century, a barn in around 1970 and the cottage in 1983.

> We have seven letting rooms, five above the pub and two in the coach house, which was built in 1862. When we took it over the forward bookings until the end of

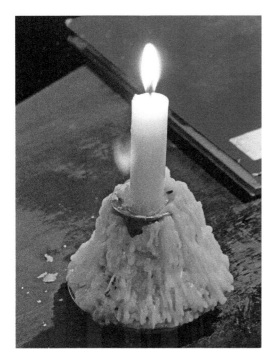

Above left: The candle is lit, and the George is open for business.

Above right: J. B. Priestley's favourite spot.

Some of the accommodation.

time were 16 in total. As soon as we came folk started coming back and walking organisations saw we were back open for business.

We have arguably the best chef in the Dales here too. The pub has a good reputation and the locals are coming in. Seventeen people live in Hubberholme but folk come down from Buckden and all around. The place is buzzing. Before we came here there was talk about a change of use for the George and making it a private residence. It has been a pub for 300 years and hopefully we will be lucky enough to have it for the next twenty or thirty years. It isn't up to us to change its traditional use; we are going to love and nurture it and keep it how it was. And it is working.

Ed's background is in sales, exports, development, mergers and acquisitions. He ran a successful business and wanted to bring those skills to the Dales. He says the hardest thing was persuading the bank to finance someone who had no experience in the pub industry. 'It isn't about experience, it is expertise,' he said:

The last incumbent had the first but wasn't successful. I had business acumen and my plan was based on opening the door, serving good beer and food, offering bed and breakfast and having good banter. Basically, being nice to people!

They didn't think being nice to people was a business plan - but customer service is key I said and we managed to persuade them. It has gone well and they are happy too.

The George is steeped in history, as is Hubberholme. St Michael and All Angels Church date back to the twelfth century and was originally a Forest Chapel of Norman origin. Tradition is also key and the annual land-letting auction known as the Hubberholme Parliament still is practised today. Ed commented:

There are 16 acres of pasture up the road that was bequeathed to the parish back in the early nineteenth century … As part of that donation, it has to be auctioned on an annual basis and at an annual meeting of the Hubberholme Parliament. The landlord of the George arranges the meeting with the vicar and it usually takes place on the first Monday of January. A service at the church is held to celebrate the forthcoming land letting and then the vicar comes across to the pub with a couple of wardens.

He asks if the landlord has prepared the candle, it is then lit and that signals the start of the auction. Anyone can come and bid for the 16 acres of pasture land and when the candle goes out, whoever has the highest bid wins it and hands over the money to the church.

They get the rights to graze the land and the church is obliged to share out the money to the poor in the parish. Traditionally, it has raised about £350 but in the last two years that has been £632 and £1,050. Given that on 16 acres of land you can only graze around twenty-six sheep, you have to make forty quid profit per sheep just to break even. It's not a lucrative commercial venture but part of tradition and history. And it helps those in need in the parish.

Ed bids me farewell as I head down to the river to take a few more pictures. As I left he said: 'It is the best pub in the world – and we have the keys.' You can't argue with that.

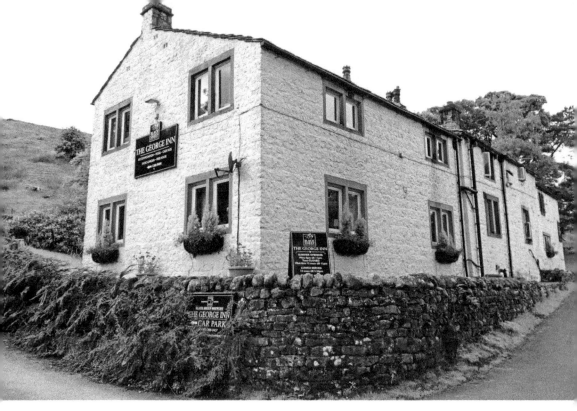

The George Inn at Hubberholme.

The Pub

Address: The George Inn, Hubberholme, Skipton, North Yorkshire, BD23 5JE.
Website: www.thegeorge-inn.co.uk

The Walk

Start Point: The George Inn.
Destination: Circular route taking in Yockenthwaite and Cray.
Distance: Approximately 5.5 miles.
The Route: From The George, cross the bridge and take the track next to the church. Follow the path (The Dales Way) that hugs the side of the River Wharfe and passes Rais and Strans Woods. At Yockenthwaite, take the path that climbs the fell (SD90579) before it then arcs back towards Hubberholme. This gives great views of the valley. Keep on this route (ignoring the obvious path to your right at SD920789) as it hugs the wall and passes above Hubberholme and Todd's Woods. After the last wood the path will begin to drop down into Cray. Before you reach the village a path is seen off to the right (SD940791) – take it, it will pass through Cray Gill before heading back to the road. Here, turn right and the short stretch of road will take you back to Hubberholme. Alternatively, you can stay on the path and head to Cray before walking back along the road to The George.

9. The Buck Inn, Buckden

The Buck Inn is a former Georgian coaching house and restaurant in the beautiful village of Buckden. Behind it rises the impressive 2,303 feet of Buckden Pike, making a pint and a walk the perfect combination.

Ivy clad, the pub was built in the eighteenth century and has undergone some significant changes, especially in the last three or so years. Landlady Michelle took

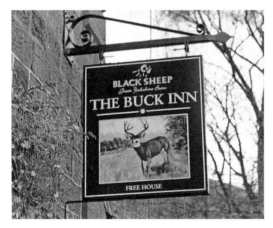

Not one...

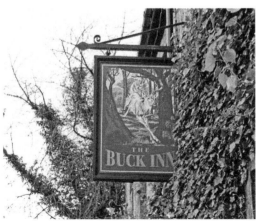

but two hanging signs for The Buck Inn.

over the inn in 2012 following a long period of closure and has invested in the facilities to make it attractive to locals, tourists and walkers.

She says there was no roof on one section of the pub during a period of restoration but once it was added and the rooms dried out, letting began. Now the Buck has twelve rooms, all en-suite. The pub has a very cosy feel and is spacious but with two distinct areas. Climbing up the steps, the bar is in front of you, effectively in the top right-hand corner and directly opposite that is a 'snug' area. It has cycling wallpaper – it's tasteful though – highlighting not only its ideal position as a destination if you're on two wheels, but paying homage to the Tour De France that came through Buckden in July 2014.

On the other side, the left, is a stone walled fireplace and wooden floor. It's a lot more open here and the decor is different too. You can perhaps hide away next to the bar on the right, but on this side it's easy to socialise. And this is what Michelle wants, too. Much like the Farmers Arms in Muker, she shuns mobile phones but will offer free Wi-Fi as long as it isn't used for Skype and other communicative methods that are noisy.

Distinctive decor taking full advantage of the number of cyclists visiting the Dales post the Tour de France.

A roaring fire.

The Pub

Address: The Buck Inn, Buckden, Upper Wharfedale, North Yorkshire BD23 5JA.
Website: www.buckinnbuckden.co.uk

The Walk

Start Point: The Buck Inn (but park at the National Park Car Park near the pub).
Destination: Buckden Pike.
Distance: Approximately 5 miles.
The Route: From the car park, head towards the gate and climb up through Buckden Wood enjoying the fantastic views down the valley. As the path heads along Buckden Rake take an obvious path right (SD940784) to Buckden Pike. Head south from the summit cairn until you read a small path on your right-hand side. This descends the Pike through some mine workings. Keep descending – effectively going away from the pub until a path appears on your right. This too goes away from the pub (SD950767) before arcing back to the car park.

10. The King's Head, Kettlewell

Kettlewell is, most of the time, a sedate village on the Dales Way. Situated on the banks of the River Wharfe it is a typical country village with stores, cafés and pubs. In winter it's almost as if no one has heard of it. Cyclists pass through on the way to Buckden and beyond, and a few walkers will amble along the river. In summer that changes as the car park fills up and it's hustling and bustling with people. This isn't a bad thing though as it is when it's busy that Kettlewell comes alive.

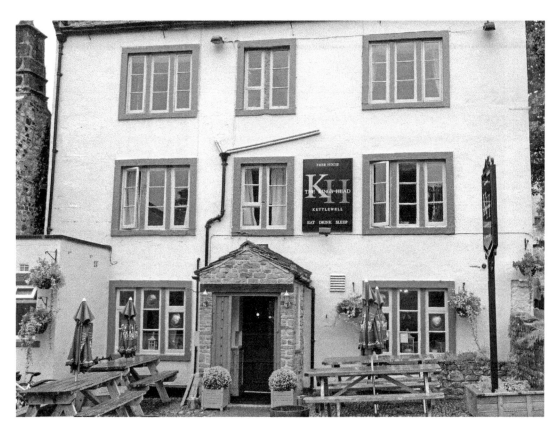

The King's Head is opposite a former market place in Kettlewell.

Who wouldn't want to sit here after a long day on the fell?

Anglo-Saxons inhabited the area and the village's name comes from 'Cetel Wella', which means a bubbling spring or stream. Evidence of this can be seen in the fields to the south of the village and traces of Romans being in the area have also been found. Cotton production and lead mining brought prosperity to the village and as a result in 1838, Kettlewell had five inns.

At present, there are three in the village and the King's Head is its newest. Closed for a while, it was resurrected in 2014 by Michael and Jenny Pighills, a chef and former schoolteacher respectively. It's hidden away somewhat – opposite the site of what was once a busy market selling corn – but that adds to the charm. Inside, it has a bistro feel, with stone floors and you're immediately attracted to the large open fireplace on the left. To the right is a dining area and ahead of that fireplace is another area for diners. Ok, this is a diners' pub really – dogs aren't welcome – but if you're looking for really good food it is the place to be. Food is sourced locally and the chef and owner used to be at the Angel in Hetton.

In such a short space of the time it has been ranked by *The Sunday Times* as a top ten pub in its Ultimate 100 British Hotels and it won *The Craven Herald*'s Restaurant of the Year in 2014. It is successful because it offers beer and Yorkshire food with a modern twist, and it is taking advantage of the cycling and walking boom provided by the 2014 Grand Depart.

There are two other great pubs in Kettlewell that are well worth a visit also. The Racehorses Hotel is back towards the road, near the bridge. It is an eighteenth-century inn just tucked away on the left-hand side as you make your way through the village.

More obvious in terms of a building that is visually appealing is the Blue Bell Inn. It is the village's oldest and probably most striking inn and has a lovely country feel.

The Pub

Address: The Green, Kettlewell, Skipton, North Yorkshire, BD23 5RD.
Website: www.thekingsheadkettlewell.co.uk

The Walk

Start Point: The New Bridge, just before the village.
Destination: Starbotton circular.
Distance: Approximately 5 miles.
The Route: Walk down from the pub to the bridge just before you enter the village (SD967722). This is before the National Park Car Park. Take the Dales Way in a north-westerly direction, following the Wharfe along its flood plain until you reach a footbridge. Take it (on the right-hand side) to Starbotton. When you get to the road, cross it, go up and left a few metres and a path on your right hand side will take you back towards Kettlewell (SD954746). Follow this path through Calfhalls, Cross Fields and Cross Wood before it arcs round and brings you back into the village. A perfect Sunday afternoon jaunt!

11. The Falcon, Arncliffe

Quirks abound in this fantastic pub based in the tranquil and sheltered Arncliffe, but this isn't a gimmicky venue to be shunned, it is a pilgrimage all walkers should make!

The Falcon was the original Woolpack in long-running soap *Emmerdale* until filming relocated to Esholt in 1976. The ITV programme shot their outside scenes around the village, no doubt because it reflected Yorkshire life perfectly. The pub for instance is ivy clad with mullioned bay windows poking out where they can to enhance its look. The village follows a similar theme, in effect making it an ideal film set.

But the way it serves its beer is the real treat here and well worth the journey. In fact, should you choose to walk to The Falcon on the Monk's Road from Malham,

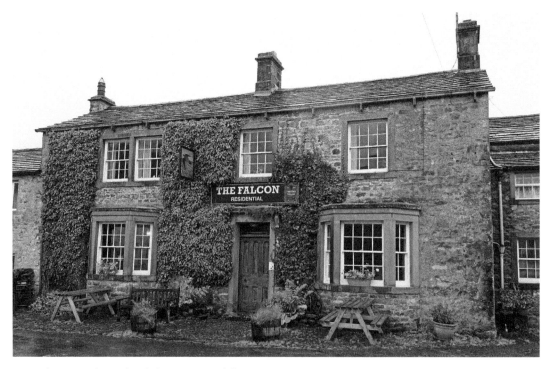

The original Woolpack from *Emmerdale*.

some 8 miles way, you deserve it. This is a pub that has shunned modern traits, while retaining its overall feel and without being too old fashioned. The bar is tiny in comparison to modern pubs and there is a small room to the left that is more than likely used by locals. At the back is a larger oblong room and it's thought that the last changes to these two rooms probably occurred in the 1950s.

The front rooms are for residents only; one being a large sitting room that looks very comfortable indeed.

While other beers are available, the ale of choice, Timothy Taylor's Boltmaker, is served in the time-honoured traditional way – from a jug. It is decanted from the cask in the back room and then poured from that jug, when ordered, into your glass. It gives the ale a chance to breathe and certainly brings out its flavour at room temperature. If you prefer your beer fresher, Boltmaker is also dispensed from one of the hand pulled pumps while another serves a guest beer from local brewery, which changes frequently. There are also more than thirty whiskies to choose from as well as the typical Yorkshire fayre.

The Falcon's homely stance doesn't end there though, as it has 2 miles of double-bank fly fishing on the River Skirfare. This isn't artificially stocked as wild brown trout occur naturally.

Arncliffe, which is in the valley of Littondale, was first mentioned in the Domesday Book and its name is of Old English origin, meaning 'eagles' cliff' – with limestone all around it's easy to see how it got its name.

A gem of a village and a gem of a pub.

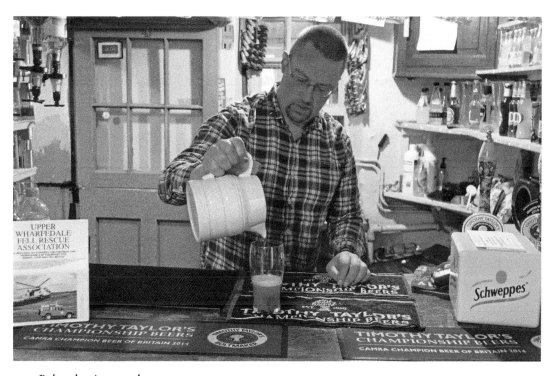

Boltmaker is poured.

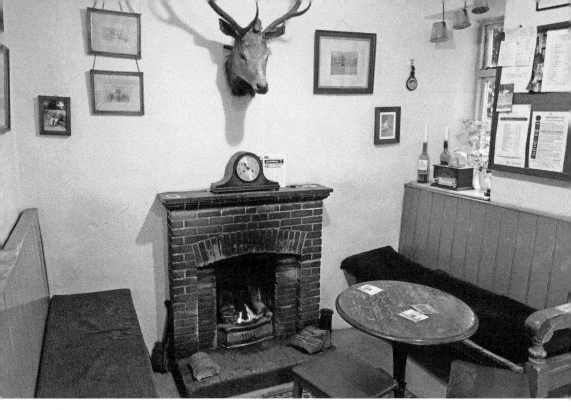

Traditional snug to the left of the bar is functional, not glamorous.

The Pub

Address: The Falcon Inn, Arncliffe, Littondale, Yorkshire Dales, BD23 5QE.
Website: www.thefalconinn.com

The Walk

Start Point: The Falcon Inn.
Destination: Malham.
Distance: 7.5 miles (linear).
The Route: This route follows the Monk's Road which drops you 'onto' Malham Tarn. From there, the paths link up with Malham Cove to Malham itself. The Monk's Path is actually to the right of the pub (SD931718) and is on a high level. It was used by the monks to access the land they owned in the Lakes and Dales. The Road is well signposted and takes you through some stunning Bronze, Iron Age and Saxon settlements. Eventually reaching Low Midge Hills you will go left and then right (SD907677) before reaching the top of Malham Tarn. From here, walk south towards the foot of the Tarn and across the road to Water Sinks – where water flows into the ground – and the Watlowes and follow the route down the Pennine Way to Malham Cove. Then, pick your way down to Malham Village and the Buck Inn – another pub in this book.

12. The Buck Inn, Malham

The Buck Inn in Malham is a pub you cannot fail to spot when you're in the village. From the Yorkshire Dales National Park Information Centre it is on your left as you head towards Malham Cove. It dominates this part of the village and is simply a big building in a small place!

Built in 1874 on the site of an old coaching inn – and now Grade II listed – it retains those historic and sepia features in one half of the pub at least. Internally, the left-hand side of the pub has that older feel: high ceilings, quite dramatic but rustic chandeliers, and red wallpaper. The chandeliers aren't in the *Only Fools and Horses* mode but are large cylindrical ones with six lights. They are suspended by a hook from the ceiling. Pictures adorn the walls too, from the usual landscapes to others depicting bygone times.

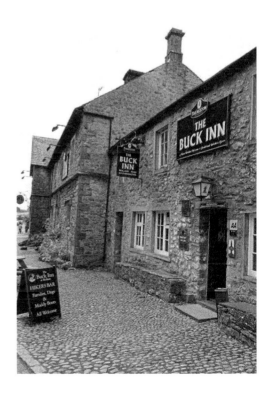

The Buck even has a Hikers Bar.

It's a little 'coffee shop' inside, but it works.

The more traditional side of the pub.

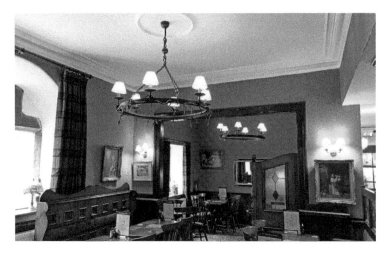

The chandeliers.

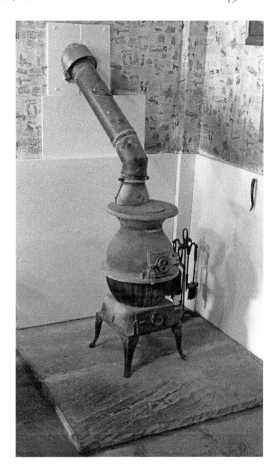

A fantastic stove to keep you warm – a great feature.

The right-hand side of the pub has a more airy, modern feel. The wallpaper is made up from old newspaper adverts and there is a large free-standing wood/multi-fuel burner which dominates the room. It is a superb addition and no doubt a godsend in the winter. This part of The Buck Inn has been named the Hikers' Bar and features a Yorkshire flagstone floor – an ideal place to visit if you're filthy and your dog is as well. Some walkers may find that this room resembles a new coffee house and to be fair it does. It's in keeping with what you would find in any town in Britain. But coupled with the older side of the Buck, and the fact it serves decent hand pulled beer, it kind of works. Give it a try.

The food also adopts the historical and earthy feel of the pub. It's famous Malham and Masham Pie is made with chunks of beef steak and Old Peculier gravy. Chef Vince Farrelly makes every single one and the pub has sold up to 500 at busy periods. Ingredients are also proudly sourced locally. According to the pub's website:

David Parker from Settle shoots all our wild rabbits, Lamb comes from the farm shop in Airton or Mark Throup's farm on Malham Moor. Trout is caught by the landlord John and his mate Owen. Fresh eggs come from the Bollands and the Darwins in Kirkby Malham and Sue Bolland bakes all our scones.

Finally all our beef and pork and some game come from Drake and Macefield who are without doubt one of the best butchers in North Yorkshire. Steaks are hung for a minimum of twenty-one days and the chunks of beef that go into the Malham and Masham pies will melt in your mouth.

Grand talk, but the pub is busy most evenings and that shows the proof is in the eating…

The Pub

Address: The Buck Inn, Cove Rd, Malham, Skipton, Yorkshire BD23 4DA.
Website: www.thebuckinnmalham.co.uk

The Walk

Start Point: The Buck Inn.
Destination: Janet's Foss, Gordale Scar, Malham Cove (circular).
Distance: 6.5 miles.
The Route: This is a very popular route but one in which you will certainly deserve a drink in The Buck afterwards! Your first stop is Janet's Foss – a small waterfall and plunge pool not far from Malham and Gordale Scar. Walk right once leaving The Buck Inn and down the village to join the Pennine Way path and then turn left along the aptly named Riverside Path. You pass alongside Little Gordale and Stony Bank Wood before meeting the Foss (SD912633) which feeds Gordale Beck. From there, head up the obvious path on the left hand side to join the road. Turn right onto this track and then go through the gate on your left after the road bends right. This takes you to Gordale Scar (SD915641) – a deep ravine formed during the Ice Ages by either meltwater cutting through the rock or it creating a cavern that has since collapsed. Climb the waterfalls (always better in drier times!) and follow the route at the top until it reaches the road. Again, take this and turn left at the top to walk to the foot of Malham Tarn (SD894661). Malham Tarn is a glacial lake formed by moraine damning it as a glacier retreated around 10,000 years ago. From here, retrace your steps back down to the road and follow the Pennine Way to where the water sinks into the ground, through the dry Watlowes and to the head of Malham Cove. At 260 feet from top to bottom it's an impressive sight and during Storm Desmond in 2016 actually featured a waterfall for the first time in 300 years! 400 steps on the left hand side take you back down to its bottom – and then the long walk back to Malham begins. A gem.

13. Tennant Arms, Kilnsey

For dramatic locations, few pubs can match the Tennant at Kilnsey. Some may boast to be the highest and remotest in the country, while others could proclaim to be the most visually stunning, but they certainly won't have such an impressive backdrop as this.

Stretching up, shadowing and dwarfing the building is the 170 feet of limestone that makes Kilnsey Crag, a mecca for adventure seekers and wildlife. Watching climbers spend forever choosing their route up the rock and then picking their way upwards is worth an afternoon alone. Delicate foot placement is always key, but it's the precision of their craft that is most mind boggling, and alluring.

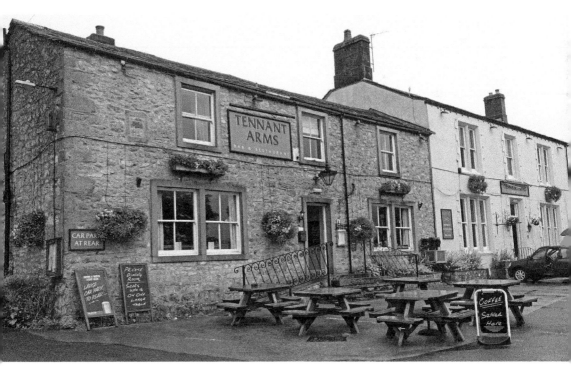

Seventeenth-century coaching house on the left and more 'modern' guest accommodation on the right.

The pub itself was built in the seventeenth century as a coaching inn for travellers passing through Wharfedale and beyond. There are two parts: the public bar area on the left and on the right the residents' rooms with high ceilings and somewhat grand decor that fits in with the building. This is the hotel part of the overall pub and clearly built at a different time to the main inn on the left.

The first entrance inside leads to the main bar with its stunning fireplace and stone floors. Further on is the Anglers Bar – an homage to the trout fishing that is available to the left of the pub. There is also a wood room nearby; this is a pub with lots of nooks and crannies and some fantastic upright beam features that again depict its age.

Some of the decor and exhibits won't be to everyone's taste, but this is a country pub in an area where hunting and shooting would have been prevalent over the years. There are a pair of peregrine falcons in a glass case in one of the bars while a pair of very rare albino otters are high up in a case near the reception area. The box has the date of 1840 on it.

Like most pubs in the area, the beer is kept well and there is plenty of choice. They also pay tribute to the Tour De France that came through Kilnsey in 2015 with a great picture display in the hotel area.

There's also plenty of walking too: west of the Tennant Arms is the historic Mastiles Lane, a Roman road that was later used for drovers to move Fountains Abbey flocks to summer pasture on higher ground.

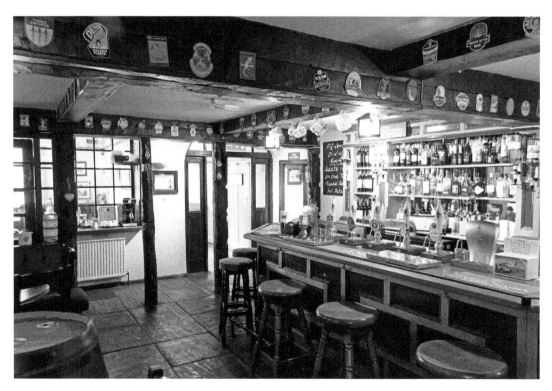

Bar area with upright wooden beams. The bar continues through the door on the left too.

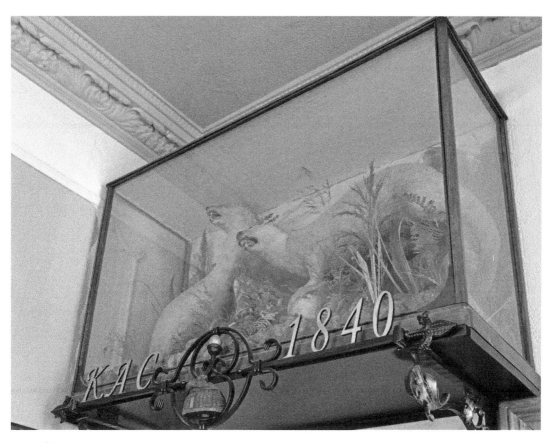

Albino otters.

The Pub

Address: Tennant Arms, Kilnsey, BD23 5PS.
Website: Not Available

The Walk

Start Point: Tennant Arms.
Destination: Kilnsey Crag.
Distance: Less than a mile.
The Route: Leave the Tennant Arms and turn left. Kilnsey Crag overlooks the road and is around 170 feet high, with an overhang of 40 feet. It is very popular with climbers and in the summer is a great place to watch these sportspeople and the wildlife that inhabits the crag. Just up the road from the Crag is Scar Lathe and from there it is possible to take a path down to Conistone Bridge and see the Wharfe.

14. The Devonshire, Grassington

Grassington is one of the most iconic villages in the Dales. It was granted market town status in the thirteenth century which made it a local hub for the trading of goods – it still proves to be such a destination today. Although stalls on the small cobbled square disappeared some 600 years later, the Dickensian festival each Christmas reignites those past days. For three Saturdays before the festive period, the village is bedecked with Christmas lights and a market with shopkeepers dressed in Victorian costumes selling traditional goods.

For walkers, there are several reasons why Grassington is important. The Dales Way passes through the village, Linton Falls are staggeringly beautiful and there are some great pubs too! The Forresters is certainly worth a visit. Taking the first of the two roads when you immediately come into the village, this great pub is on your right as the road begins to rise. It's a rustic-looking, old-fashioned building with great beer. But it is the hotel on the left-hand side, further down the hill that really caught my eye.

The Devonshire is unmissable in Grassington. It's opposite the top of the cobbled square and dominates one flank of the village. I first visited it in late August 2015 when it had reopened following a closure that took many by surprise. It seems that the tenants upped sticks, with several people apparently booked in to stay. They arrived to find the doors closed but with the help of the local community and businesses found alternative places to stay.

There were no such problems when I visited. The bar was on the right as I came into the inn, with a really comfortable snug just before it, up a couple of steps. The barman seemed pretty happy with his lot and there was a waitress braving the slightly chilly late summer weather outside, cleaning up the tables. Within a month though it had been bought by brewer Timothy Taylor and closed to undergo a transformation.

In December 2015, it reopened thanks to Keighley based company RN Wooler, who completely revitalised its interior alongside operator Pickles Pubs.

They were keen to ensure this historical pub retained the heritage and tradition that made it popular but not to the detriment of modern day visitors who might have expected something a little cleaner and up to date. And you'll see, from the hanging signs pictured overleaf, the difference pre-September 2015 to now. This pub has been given its mojo back.

Above: The former Devonshire.

Below: The new Devonshire.

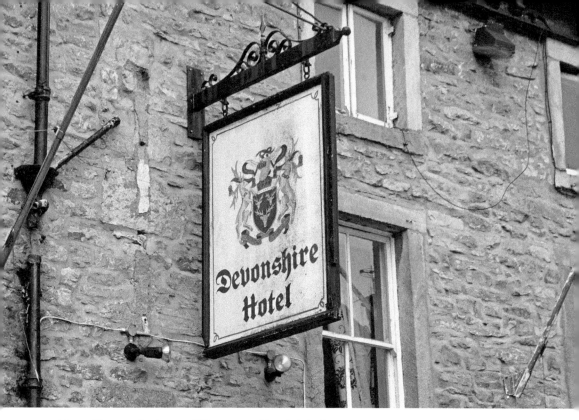

Above: The exterior is very different too. Here it is before.

Below: Then after.

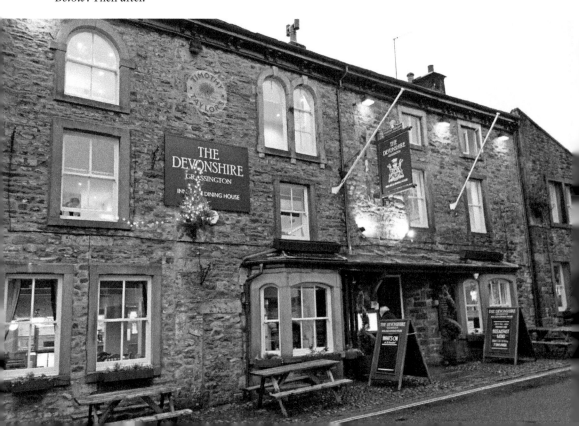

The age of The Devonshire is difficult to determine. It probably dates from between the seventeenth and eighteenth centuries because it is in keeping with the buildings that neighbour it. One fact that will probably never change, despite being 'modernised', is its use. It has always been seen as a hub for the village. For example, it hosted an auction in 1872 as a parcel of land was sold, and three years later the Grimwith Mining Company held its AGM there. The Devonshire and meetings went hand in hand in the late nineteenth century.

The interior is now in complete contrast to that of just a few months earlier. When I first visited it was a dark but homely place – certainly comfortable enough for muddy walkers to take their rest. As with most new pubs, they've retained that comfortable feel, but Wooler has made it a lot more airy and in keeping with the countryside. Tables in the restaurant area have been replaced by benches and tables. High-sided chairs near the fireplace are ideal following a long wander. There's also a wonderful painting of The Devonshire in what looks like the Victorian period on the wall. This is a pub that wants to retain its heritage and understands why Grassington is important.

Outside, the building has small bay windows and others that aren't strategically symmetrical like modern buildings. It's a perfect pub in a perfect setting. Best visited in the winter when there's a roaring fire on.

The Pub

Address: The Devonshire, 27 Main Street, Grassington, BD23 5AD.
Website: www.thedevonshiregrassington.co.uk

The Walk

Start Point: Grassington National Park Centre (SD002637).
Destination: Grassington, Linton Falls circular.
Distance: 4.5 miles (with good navigation inside Grass Wood!).
The Route: Turn right out of the Yorkshire Dales National Park Information Centre and then head down the road until it begins to bend to the left. There, a path to Fletcher Brow begins. Take it for a few hundred metres, then cut back towards Grassington on the Dales Way to see Linton Falls (SE004632). Follow this path, which is on the right-hand side of the river, to Ghaistrill's Strid and then into Grass Wood – an ancient forest. Note that the Dales Way heads through Grassington at the main bridge into the village, avoid that one and stay on the river side. Once in Grass Wood the key is to head north to pick up the path near Gregory Scar. The best way to do this is to head to Far Gregory and then Gregory Scar, following the paths to the settlement at around SD994651. From there, you're picking up the path to Cove Lane and before it throws a sharp right taking the path through to West Barn (SD999647) and eventually the Dales Way. This takes you back into the village of Grassington. Going away from the Dales Way and not heading to Grassington at this point can lead to the sites of medieval villages.

15. The Fountaine Inn, Linton

In 1660, a young man from the village of Linton went to London to seek his fortune. He became a timber merchant and, as luck would have it, held that occupation during two major events in the history of London, ironically when that commodity was in great demand – the plague of 1655 and the Great Fire of London the following year. He was named an alderman soon after and by the time of his death in 1721 he'd amassed a fortune.

In his will, Richard Fountaine wanted to ensure his money would be put to good use, while also giving something back to the area where he grew up. He bequeathed a large sum for a charity to be established to benefit the local community in Linton. It had three conditions: firstly, it had to be used for the benefit of the poor, and secondly to necessite the building of an almshouse – later called the Fountaine Hospital – to accommodate six poor men or women of the parish. Designed by Sir John Vanbrugh, the architect of Castle Howard, this cost £1,500.

Each beneficiary would have a small house within this hospital, with a chapel nearby that they were expected to attend whenever prayers were being taken. The qualification was, 'they shall be poor persons who have been resident in the area of the Ancient Parish of Linton in Craven for two years preceding the time of appointment.' They would also have, yearly, a gown of blue cloth lined in green.

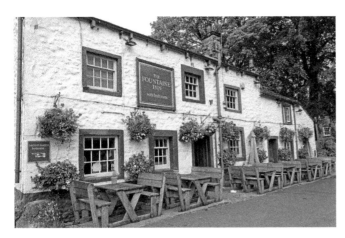

The Fountaine Inn is beautiful.

Finally, the charity would provide a fund to pay for a rector, as long as they resided in the parish and said prayers twice a week.

Today, although the gown and necessity to visit the chapel are no longer enforced, all the other requirements in Richard's will are still met. Six self-contained cottages are within the hospital and the trustees of the will – administered by twelve people from the ancient parish of Linton – have no difficulty in finding residents. The will also makes grants to students, apprentices and parish residents.

Therefore, it seems only apt that only pub in the village – The Fountaine Inn – is named after Richard. It is probably the most beautiful setting in the Dales if you're looking for something idyllic after a day's walking. With the pub at the back of you, the Fountaine Hospital is on your right. In front is the village green with babbling brook and clapper bridge built in the late nineteenth century. The houses are elegant too, with the oldest dating from the seventeenth century even though Linton itself has a longer history. Its name is derived from the flax (lin) grown in the surrounding fields. The spinning of flax was a major occupation for the women of the village leading up to the mid-eighteenth century.

The Fountaine Inn itself was likely built in the eighteenth century and is certainly snug inside. The bar area is on the left with a larger dining room up the stairs. It has a log fire, low ceilings and wooden beams. To enjoy the pub at its finest would be on a summer's day, outside, following a walk around the village. Very peaceful – and the staff are very welcoming too, as you can read below.

From Halliwell Sutcliffe's book, *The Stirling Dales* (Frederick Warne, 1929), taken with permission from the Fountaine Inn:

On each side of the hearth was an oak chair with a churchwarden pipe on the wall above it. One chair and pipe were appropriated to the Squire of Linton, who lived just beyond what had once been Daykin's House; the other to Christopher Dean, a yeoman born of yeoman ancestry went back to Elizabethan days. Whoever chanced to be sitting in one or other of the chairs must yield if its proper tenant entered; and the

All in keeping with the inn's and the village's heritage.

Lighter dining area.

Squire and Christopher would sit together on many an evening discussing tomorrow's weather or the tales of centuries long dead. Shepherds and farmers a travelling tinker, maybe, stumping in to join the company - would put in slow jest now and then. And Mary, with her wrinkled, kindly face, would stand and watch them all. They were guests of her tavern, rather than money bringers; and if her ale was ripe and nutty, so was her outlook upon men and life.

The Pub

Address: The Fountaine Inn, Linton-in-Craven, North Yorkshire, BD23 5HJ.
Website: www.fountaineinnatlinton.co.uk

The Walk

Start Point: The Fountaine Inn.
Destination: Village Circular.
Distance: As long as you like!
The Route: The village of Linton is best explored without a map or a guide. Turn right out of The Fountaine and head to the Fountaine Hospital, here you can pick up a leaflet and look around the village yourself. History and heritage abounds.

16. Red Lion Hotel, Burnsall

The Red Lion Hotel is a historic pub on the banks of the River Wharfe in pretty Burnsall. Originally a sixteenth-century ferryman's inn, the owners have managed to combine the ancient and modern in a fantastic and welcoming pub. Overlooking the bridge that takes you on to Appletreewick and beyond, it's difficult to miss, just situated on the left-hand side of the road that goes through the village. It is thought that its cellars date from the twelfth century and the original 'one up, one down' part of the building – which is now the bar area on your left as you enter – from the sixteenth century. Since then, it has been extended but the owners have been keen to ensure its heritage remains.

The Red Lion's place as a hub for travellers is also apparent by the horse trough, which would have stood outside the front door and is now under the stone steps that guests take to their bedrooms. The weight of the trough would have been so much that

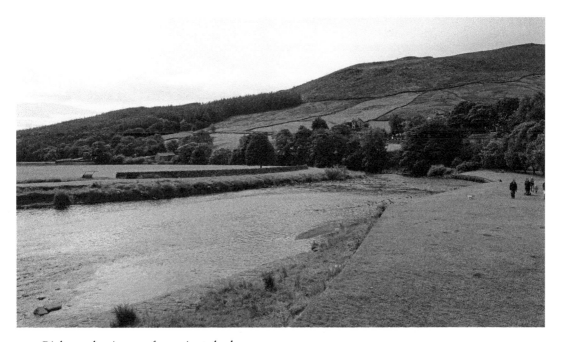

Right on the river – a fantastic outlook.

it was deemed a lot easier to build around it than move it. There are quite a lot of these historical features throughout the pub too. It has original beams remaining, the floor slopes and creaks, and the decor is not over the top. The bar itself has been traditionally panelled and floored in oak and the food is locally sourced, as you would expect.

It is also, refreshingly, run by a large family who all pitch in to help. The Grayshon family bought the pub in 1991 and have recruited their daughters and in-laws to run it. The original buyers, Andrew and Elizabeth, have now retired and live at the old post office in the village. In their place are their four daughters and their partners. The pub's website reads,

> Eldest daughter Sarah organises all the weddings. Victoria is in charge of all accounts and her husband Jim is bar manager. The youngest daughters are twins Katy and Eleanor who deal with all staff, marketing and conferences. Katy is married to head chef Olivier and Eleanor's husband Charlie is second in charge in the kitchen. Even our children are now involved, with Sarah's daughter Alice helping to serve breakfasts and Katy's youngest daughter Mary (aged nine-years-old) working in the office on a Sunday morning!

It's great to see the family and the business thriving, not only has a manor house built in 1883 that serves pizza, 'dine in or take out', but also holiday cottages to rent.

Burnsall itself is on the Dales Way and its name is derived from 'the hall by the burn' or in reference to the ruler of a chief. The affix, Sal, in Danish means the chief room or hall, hence 'Burns' 'Room'. It was all but destroyed during the Anglican rebellion and subsequent uprising suppression events. Robert de Romille then took possession of Skipton and the area, and the village's church – St Wilfrid – does have relics of this time. It was repaired by Sir William Craven, Lord Mayor of London, who on his return to the area also built the school.

He was born to a pauper's family in Appletreeweek, a stone's throw from Burnsall, and it is suggested that he was the inspiration behind some versions of the folk tale Dick Whittington.

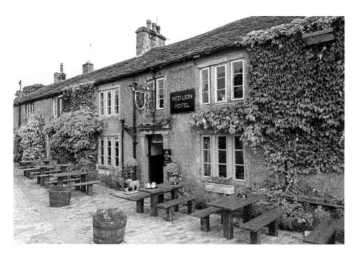

The cellars here possibly date from the twelfth century.

Lovely snug.

The Pub

Address: By The Bridge at Burnsall, near Skipton, North Yorkshire, BD23 6BU.
Website: www.redlion.co.uk

The Walk

Start Point: Red Lion Hotel.
Destination: Simon's Seat.
Distance: 8.5 miles.
The Route: This takes you to Simon's Seat via the Dales Way, and then back along the road through Appletreewick to Burnsall. Leave the Red Lion and turn left. Walk down to the bridge and take the path that firstly goes across the field and then hugs the left-hand side of the river. This is on the right-hand side of the bridge as you look at it. Follow the Dales Way until you reach Stangs Lane (SE059592). From here head straight forward towards Howgill. On reaching the next set of crisscross paths, continue straight, following How Beck. Once out of the wood and into a clearing turn left and follow the path, to the Grey Stone, The Devils Apronful to Simon's Seat (SE078598). Here, either retrace your steps or follow the obvious path down to Dalehead Farm. You soon reach Howgill Lane (SE072603) but don't follow it, turn right up to High Skyreholme over Blands Beck to reach Skyreholme Beck. Turn left and follow the road back through Appletreewick (check out the two magnificent pubs there) through to Burnsall.

17. The New Inn, Appletreewick

There are two fantastic pubs in Appletreewick for walkers – the first being The New Inn.

Although it isn't as old as its Craven Arms neighbour (more later), it is full of character and is normally more sedate. It takes its name because it is relatively new in a village that has history dating to the sixteenth century. A proctor date stone on the pub seems to suggest it was built in 1859 and it certainly looks out of keeping with the buildings around it.

However, that shouldn't spoil its charms. Inside, the bar is set on a higher level, up a couple of steps, while the pub itself is light and airy with an open fireplace which was certainly kicking out some heat – and a fair amount of smoke – when I called in. This would have caused some consternation to former licensee John Showers, who decreed that the pub would be smoke free in the 1970s – coming after he had already opened it up and made some significant changes to create a more social atmosphere years before.

According to Patrick Chaplin of the Pub History Society, John was a jack of all trades who'd had various careers before settling on being an hotelier. He wanted to 'lift the standard from the ordinary pub'. In his autobiography he claimed to have a mailing list of more than 15,000 customers who would each be sent a birthday or

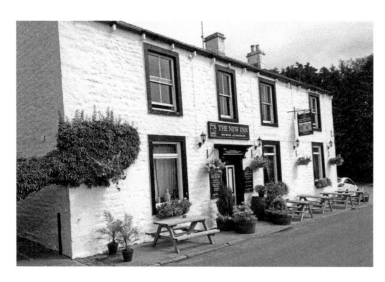

The New Inn.

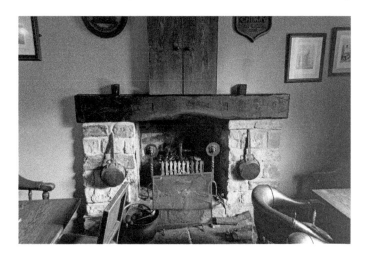

No smoking, unless it's from this.

anniversary card when the date would pop up. Overseas visitors would be welcomed with the flag and national anthem from their country of origin.

In the mid-1960s he decided to move to The New Inn and wanted to bring a Danish flair to the Dales because the area had, he said, 'many landmarks reminiscent of the Viking invasion'. Chaplin wrote:

> Renovation work went ahead with internal walls of the New Inn being torn down and smaller bars and little rooms converted into one large, spacious lounge with an up-to-date bar furnished with every modern device to ensure efficient customer service.
>
> By lavish use of wood-panelling the former village 'local' was transformed into a Danish theme pub and soon 'assumed a Scandinavian atmosphere.' To reinforce the Danish theme, Showers introduced 'Smorrebrod ('delicious open sandwiches on Danish rye bread') offering his customers more than 60 varieties of this most Danish of foods. To complete the theme, five beers brewed by Tuborg Breweries of Copenhagen were provided 'to satisfy every palate.

By all accounts it worked, as locals and visitors flocked to the pub. His next idea wasn't as popular at first but remarkably worked just as well. John wasn't fond of smoking, not because of the health problems originally, but the damage it caused to his previous establishments. It resulted in fires and cost him a small fortune in repairing carpets, upholstery and redecorating. He couldn't really do anything about it but when he lost a close friend he decided to take action. Chaplin wrote that he:

> Simply came home one night to the New Inn and cleared the bar of every cigarette, cigar and ashtray and introduced a ban on smoking for all time. This decision caused a sensation in the local and national media and news of his smoking ban spread across the world. Showers was featured on television and radio and the newspapers were full of the story. He advertised the New Inn as "England's First Fresh Air Inn" and

a notice on the door warned potential customers that they were entering "England's First Licensed Smokeless Zone." Showers proudly announced, "I had dared to split this social atom" and the reverberations were felt across the world, albeit temporarily.

Thus, The New Inn was the country's first non-smoking pub – more than thirty years before it was 'properly' introduced by legislation.

Back in 2015, although the smoke from the fire was pretty choking, it gave an ambience to the building, and just over to my left two chaps, fresh from a walk to Trollers Gill, were chatting. Life seemed pretty simple at that point and I think Showers would have approved.

Turning right when you come out of The New Inn is the historic Craven Arms. It dates back to the sixteenth century and was on Sir William Craven's estate. It has original fireplaces, low-beamed ceilings and stone-flagged floors. Originally, it was a farmhouse and, it is suggested, 'grew' into a pub because the occupant was brewing ale and selling it to passers-by and drovers off to market.

When Craven returned from London he enlarged the High Hall, made the road from Appletreewick to Burnsall, built Burnsall Bridge and Burnsall School, and repaired St Wilfrid's church. The beam in the Cruck Barn, which is behind the pub, actually came from the High Hall and his coat of arms is on the front of inn. Power is provided via gas and you can see the lights at the entrance flickering as a result. Up to 1926, the Court Leet was held at the pub, dealing with petty crimes – the village stocks are to the left of the building.

Out the back is a Cruck Barn – the first of its kind to be built in the Dales for around 400 years. It was constructed by Robert Aynesworth, a member of the family

A nod to its 'non-smoking past'.

Mountain bikes welcome.

who owns the Craven. He built it using the same methods as were used four centuries previously and it features a heather thatched roof, lime and horsehair plaster, limewash and a huge log fire with sheep wool insulation. It is used for weddings, parties and other such events and is superb inside.

The Pub

Address: The New Inn, Main Street, Appletreewick, North Yorkshire, BD23 6DA.
Website: www.the-new-inn-appletreewick.com
The Full Showers Article: www.pubhistorysociety.co.uk/nosmoking.html

The Walk

Start Point: The New Inn.
Destination: Trollers Gill.
Distance: 5 miles.
The Route: Leave the pub, turn right and walk up the road towards the Craven Inn. Just beyond the pub is an obvious path, take it (Dibbles Bridge) and walk up through Breastcroft Lathe and Turbot Gate Lathe. Once here, follow the route up to the sheepfold and then turn right. The path (SE053611) forks: take the one on the left and follow it up to New Road. Here, we need to cut a path down, near Trollers Gill – a gorge so dark that people believed it to be haunted! Trolls would roll stones down the hillside into walkers. There are also tales of a devious and terrifying beast living down there! Anyway, once on the new road, follow it slightly until you see the obvious path on your right (SE063621). Take this path until it intersects another, then turn right and follow it down. Trollers Gill is on your left here. The path eventually arrives at Middle Skyreholme and then it's a simple walk back along the road to The New Inn.

18. The Angel Inn, Hetton

The Angel Inn is a real gastropub that blends traditional Yorkshire Dales flair with continental charm. Dominating the small village of Hetton, it can trace its origins back to the fifteenth century and, like most in the National Park, was no doubt a drovers' inn that also served travellers as the years progressed. It is large in size and has a wine cave or 'auberge' that people can dine in. Most of the inn was extended in the early eighteenth century because it served the communities around the village as well as Rylstone and Cracoe, and it probably retained its status as a traditional farmhouse pub well into the 1960s before it became popular with customers wanting good quality food. Customers would travel from far and wide to sample deep fried whitebait, ham and eggs, and steak and chips. Sadly, as the owners moved on the public did too, until it was bought by Denis and Juliet Watkins in 1983.

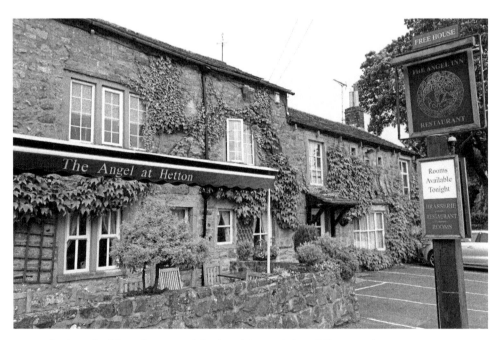

Dating back to the fifteenth century, The Angel is certainly a different pub now.

Denis had experience in running successful hotels and he'd organised Britain's first ever World Wine Fair in 1978. Much like John Showers' revolution at The New Inn some 8 miles away a decade or so earlier, the pair wanted to revolutionise pub grub and served 'mange tout and fresh new potatoes with every dish going out into the bar' instead of chips. They wanted to help people find good food as well as great value for money, away from the usual and traditional pub fayre.

It took time but it worked, and before Denis' death in 2004 he won a 'Catey' award – a food Oscar – for the best Pub Operator in the country. He was called the godfather of the gastropub. That legacy continues today and The Angel not only serves fantastic food for visitors – and walkers – but good quality wine and beer too.

The Angel's heritage can be seen throughout with low beams, copious wood and loads of nooks and crannies. On the left-hand side is a small bar, while places to eat are numerous in clean surroundings. It manages to retain the look of an old pub, and that is important, as it nods towards its heritage.

Fireplaces throughout...

Beams feature heavily too.

Stunning bar.

Juliet's son Pascal, who runs the marketing and front of house, and her team not only believe in good traditional food, but also promoting good quality regional art too. Art in the bar showcases some of the best artists from the north of England who display their work not only in this country but internationally too. The art on show is high quality and for sale. It is put together with the help of Masham Gallery and features landscapes, special work in acrylic and inks, prints and oils. It is well worth checking out The Angel's website before popping in to see what is on view.

It may sound like The Angel isn't ideal for walkers, but that's far from the truth. The walk around Hetton and Cracoe takes in some stunning landscape and it's nigh on impossible not to be inspired by the sweeping moors and dale. To then see some of that transpired into works of art, over a good quality pint, is something not to be missed. The Angel deserves credit for trying to move away from the traditional country pub that serves food by making the experience cultural, while also maintaining the heritage of an inn in the Dales.

The Pub

Address: The Angel Inn, Hetton, Near Skipton, North Yorkshire, BD23 6LT.
Website: www.angelhetton.co.uk

The Walk

Start Point: The Angel Inn.
Destination: Circular to Cracoe.
Distance: 6 miles.
The Route: Leave the pub and turn left. Head past Moor Lane on your left and then turn right to follow the road down to Rylstone. Take the B6265 until you reach the fifth field and see a path on the left (it is the first path you come to – SD971582). Follow this route and take the right-hand path after it turns to the right. This takes you to Sun Moor Hill. When you reach High Bark turn left (SD984570) and follow the wall past Rylstone Cross to Watt Crag, the war memorial and obelisk. It can be pretty muddy here, so take care. Just before you hit The Crags, turn left (SD995594) and cut down the fell, past Three Thorn Well to arrive at Fell Lane. This takes you to Cracoe. From there, follow the road (on the right) back to Hetton.

19. The Crown, Horton-in-Ribblesdale

Horton-in-Ribblesdale is the traditional start, and end, of the Yorkshire Three Peaks walk. It's a circular route that takes in Pen-y-Ghent, Whernside and Ingleborough, climbing more than 5,000 feet and around 25 miles in length. During summer weekends the village is swamped with visitors, the Yorkshire Dales National Car Park is full, cars spill onto the side of roads and verges, and opportunistic landowners provide parking on fields for the walkers.

Although most Three Peaks walkers will bring their own provisions to the area, both the Golden Lion and The Crown are vibrant and busy in the afternoon and positively thriving in the evening. The Lion is on your left if you are travelling into the village from Settle while The Crown is just to the right of a small road bridge that spans the River Ribble. It is one of few hotels and inns that is actually on the Pennine Way itself. Visiting these pubs during three peak season is a decision you make 'warned' as it is also the busy season, but well worth the trip. However, The Crown in particular is a delight as the nights draw in and the village is a little quieter.

One December evening, I'd opted to take the short walk from the centre of Horton, along the green lane to Hull Pot and then come back over Whitber and finally past Sell

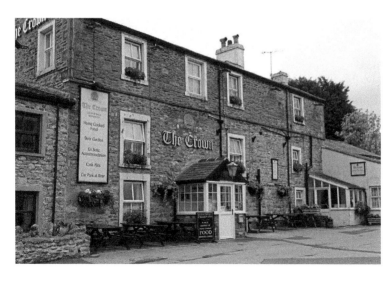

The Crown.

Gill Holes into the village. It was cold and misty but nothing too serious as my head torch picked its way through the night. After a while, once my nerves had held up to every single stone shift and noise in the night, it began to rain. Nothing too heavy but by the time I came back into Horton, it was pretty miserable and I was too. In the distance, lit up like a beacon, was the Crown.

I left my backpack by the porch, opened the door and walked in to a wall of intense heat and an even more intense dominos match. I ordered a pint of Black Sheep and watched the game against what seemed to be The New Inn of Clapham. Silence was the order of the night, with only the slight mutterings for 'knocking' and the lifting of glasses. This was a true local's pub – one chap had an iron tankard – but I was made to feel very welcome. After a chat about the weather, more games took place, hands were shaken, points noted and then the cycle started again as players moved on to their next match. It was a fascinating watch as the beer went down well and I dried out.

The Crown has offered travellers in the area respite and refreshment since the 1600s and for the last forty years or so, three generations of the same family have continued that tradition. It is now run by Sandra and Thomas Millman who admit that they aren't running a five-star hotel but a small, cosy, and clean country inn – ideal for walkers. In 1932, The Crown marketed itself as having an 'electric light, a bath and a piano all adding to the ambience'. It had been recently 'renovated and enlarged' and offered 'comfort, convenience and courtesy'. The article went on to read, 'First-class accommodation for visitors at most reasonable terms. Electric light, bath, piano, fishing, four minutes from the station.' How times have changed, although I couldn't find the piano when I was in there…

Rural areas have to adapt to modern habits of visitors and Horton is no different. The Crown, Lion and the Pen-y-Ghent café are very well known to visitors but the village cannot support a local shop that was also the post office. This is now in The Crown itself for two days a week, demonstrating that the power of a pub as a community asset cannot be underestimated.

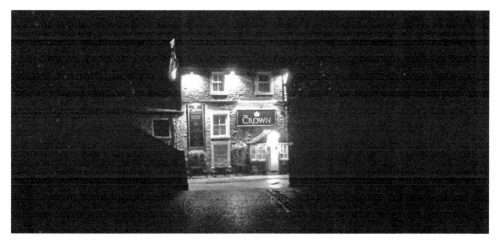

A night beacon!

An intense game.

The Pub

Address: The Crown, Hawes Road, Horton in Ribblesdale, BD24 0HF.
Website: www.crown-hotel.co.uk

The Walk

Start Point: The Crown (park at the Yorkshire Dales National Car Park).
Destination: Pen-Y-Ghent Circular.
Distance: 7 miles.
The Route: Take the path that is on the right-hand side of the pub up towards Sell Gill. Rocky in places, it soon opens out into an area where you will hear rushing water. These are Sell Gill Holes with a large drop on the left-hand side and the more damp entrance on the right. Continuing up the path (the Pennine Way – ignore the one that drops down the valley, which is the Ribble Way) it levels off until it is joined by an obvious path from the right. This is the new Whitber Path (SD810748), designed to take Three Peaks traffic away from Black Dubb Moss. Follow this path until it comes out into a large clearing. Here are several routes. Straight ahead is the path up to Pen-Y-Ghent and to the right is the route back to Horton-in-Ribblesdale. For now, take the less distinct path left and take a look at Hull Pot (SD824745). Retrace your steps and head up the path to Pen-Y-Ghent, pausing to have a little look at Hunt Pot on the right (a small trail leads off the path). Once on the summit of Pen-Y-Ghent (SD838733) head down the newly paved surface to a slight scramble – take care here. As you reach the bottom there is a route on your right back down to Brackenbottom, take it and this will bring you to a road in roughly a mile or so. Go right, down the track, past the school and back into Horton.

20. The Game Cock Inn, Austwick

You know a pub is a destination for walkers when you walk through the front door and cannot get served because a rambling club has occupied the bar.

It was September 2015 and I'd just come off Norber to have a quick pint of Thwaites' Wainwright following a superb day off the hill. Sadly, I couldn't get near enough to order first time round as three of the group were also waiting to be served while their friends deciphered a map. The wait was worth it though as the walkers spoke about their love of The Game Cock and also the sheer number of routes they had taken from and to Austwick: some had been up to Norber while others had tackled Ingleborough from the pub too – that's not a short wander by any means.

The Game Cock Inn – food with a French twist.

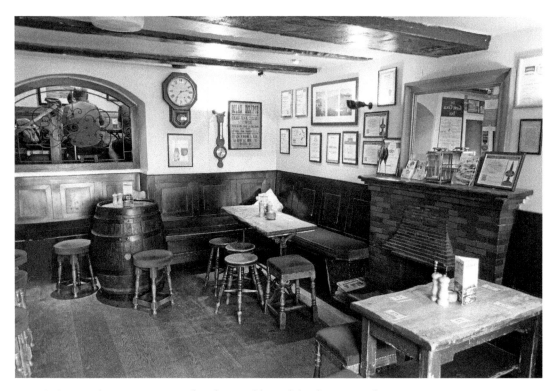

Quiet now, but it was crammed with a ramblers' club when I visited.

The Wainwright was fantastic, as it always is, and the pub was buzzing for a weekday afternoon. Run by Eric, Maree and family, the inn bills itself as 'traditional with a French twist'. There's plenty of the usual here but on certain evenings during the week they focus their food on the Breton and Brittany regions and also hold a French night midweek. Beer is sourced from Thwaites while the bar area has wooden flooring and seating around the walls to enhance its size. Furniture is also in keeping with a pub of its age. Outside the bar area, and further on into the pub, are places to sit and dine – a wonderful elevated platform almost offering privacy away from the main area.

Walking isn't just restricted to the hills as the area around Austwick has evidence of human habitation that is more than 4,000 years old. Archaeology had found prehistoric burials as well as Bronze and Iron Age settlements. It also has extensive structures built of local stones such as slate and sandstone as well as the ubiquitous limestone. In the Domesday Book the village was the head of twelve manors.

The Pub

Address: The Game Cock Inn, Austwick, Lancaster, LA2 8BB.
Website: www.gamecockinn.co.uk

The Walk

Start Point: The Game Cock Inn.
Destination: Norber and the erratics.
Distance: 4.5 miles.
The Route: Leave the pub and turn left down the road. Once you have passed the school, turn left and go up the road until it reaches a crossroads with a dirt track intersecting it. Turn left and then take the path on the right-hand side up through Dear Bought Plantation. Climb and go through a small gate, then go right, off the beaten track by hugging the wall which should be on your right (SD768697). Continue for another few minutes or so then take a left up the hill to rejoin an obvious path. Enjoy the Norber Erratics! Cross where the walls meet in the top right-hand corner and climb up to follow a line of cairns on your left. You don't need to climb up to them but slowly gain height to enjoy the limestone chaos of the 'top' and the stunning views. Eventually, you need to make your way down and head towards Crummack. The best way to do this is to continue high and then aim for the Pennine Bridleway. Once on that route (SD765717), turn right and then right again as the next route comes into view. Follow that down and then take the long Crummack Lane. As the Lane bends right, with Nappa Scars on your right in the distance, take the path left which will take you past Norber Sike (SD771694). This route, if followed direct, crossing the dirt track at the opening of your walk, will bring you into Austwick.

The erratics at Norber. Wow.

21. The New Inn, Clapham

Clapham has always been the hub of caving in the Dales. The Cave Rescue Organisation is based here as is the famous Gaping Gill system, as well as the fantastic Ingleborough Showcave. It's also a honeypot for walkers tackling Ingleborough – in particular taking the Nature Trail through the Farrer Estate. But it is the former that The New Inn always celebrated in its interior.

Inside this eighteenth-century coaching inn, subterranean lovers would share stories of their discoveries and pictures depicted caves, potholes, caverns, pitches, tunnels, squeezes and their head-torch-wearing explorers. Some were a little risqué too, as Jim Eyres' drawing talents featured throughout. Jim was a well-known caver in the area

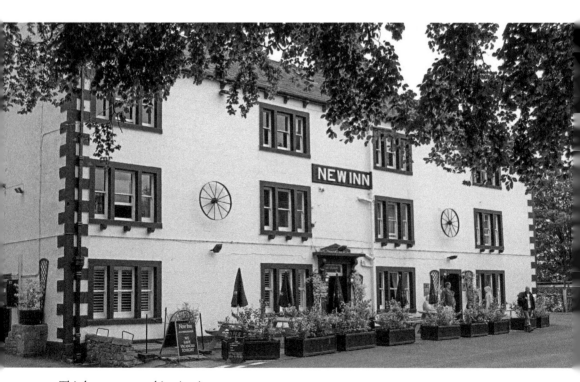

This became a coaching inn in 1745.

and his storytelling was legendary. In caving's heyday The New Inn would be chocker, the beer would flow and the laugher would follow. But over recent times, caving has become much more of a niche sport. The number of participants has decreased as younger people aren't as attracted to going underground as, say, staying at home in more comfortable surroundings on a games console. Outward Bound centres take children kayaking and abseiling, but trips to caves are few and far between. That means there are fewer people in the caves of Clapham and therefore, fewer cavers in the pub.

Coupled with the caving-heavy decor of The New Inn, this meant times needed to change if the pub was to stay busy. In all honesty, if you didn't like caving then a trip to the pub would have been a little daunting. Luckily I do. One night I heard a story of how someone's prosthetic leg was used as a belay point in the Ease Gill Cave System in Casterton. Another evening I was regaled with ropes having no knots at the end, with resultant disaster and choice language. But that's me and not everyone is as keen.

Therefore, it was no surprise that when the Benson family took over the pub in 2013, they looked to give it a much-needed revamp as well as restoring it to its former glory. Original oak beams and beautiful stone walls were made a feature and the dark and red decor in the bar areas were brightened up to bring it into the modern age.

Originally, this Grade II-pub was a farmhouse in the early 1700s but was converted into a coaching inn around 1745. In 1807, an extra floor was added to make it four storeys. The new decor aims to bring this out, being fresh inside and bright without removing some of the original features, such as large tables where people would gather

Clean, modern and very welcoming.

to swap those caving stories. The proof is in the eating – or drinking – and suffice to say the menu is top class, as is the beer. Caving may not be a prominent feature anymore but on my visit locals were stood at the bar sharing stories while your caver author didn't feel out of place covered in mud following a long walk. And, after the CRO have met next door they still pop in for a beer, so it can't all be bad. Perhaps it was just time for The New Inn to be revamped after all.

Clapham is the 'Doorway to the Dales' and never has a description been more apt. Built around Clapham Beck, the village is a bustling centre for people exploring the Dales but never gets away from the fact it is home to hundreds of local people. In fact social policies, in the past anyway, from the Farrer family, Ingleborough Estate owners, have ensured local families have had the opportunity to live in the village for affordable rents. The Farrers are also responsible for most of the beauty in the area including the woods, fields, moors and farms of the village. The nature trail takes in much of Reginald Farrer's work too in acquiring rare plants from all over the world and is a must visit before or after a visit to The New Inn.

The Pub

Address: The New Inn Clapham, Old Road, Clapham, Settle, North Yorkshire, LA2 8HH.
Website: www.newinn-clapham.co.uk

The Walk

Start Point: Yorkshire Dales National Park Car Park.
Destination: Ingleborough circular.
Distance: 9 miles.
The Route: Turn right out of the car park and walk up to the church. At the road turn right and then go up through the Ingleborough Nature Trail (don't forget to pay your fee and take a leaflet). Follow the trail out into the clearing and past the water pump on your right (thwacking sound) and the superb Ingleborough Cave on your left. Continue up the path, which gains height, to Trow Gill. There's only one way up, so follow it and then take the obvious and well-worn path to the stiles. Go over them and after a few metres you will see a dip to your left – that is Bar Pot. Don't get too close. Continue the route, past various holes, before coming to a fork. Take the route on the right and this will lead you to Gaping Gill. Cross the stream if it is safe and continue on the path up to Ingleborough. You will rapidly gain height until you reach a false summit (Little Ingleborough, SD743734) when it levels out. This will climb once more and reach Ingleborough plateau. In the mist, finding the summit cairn can be a navigational nightmare as you effectively cut back on yourself (SD741745). It's advisable to take a bearing from the cairn back to the path. Retrace your route down to Gaping Gill and the stiles but instead of turning right to go back to Trow Gill, go straight on to Clapham Bottoms, and then up to join Long Lane (SD758716). Take this lane down to an intersection, turn right, go under two tunnels and you return to Clapham to the left of the church.

22. The Station Inn, Ribblehead

Drinking after a day's toil was a regular feature of Ribblehead. When the impressive twenty-four arch viaduct that carried the Settle-Carlisle railway line was being built in around 1869, navvies would live in shanty towns and villages around Batty Moss. Figures suggest that there were 150 huts between the moss and Dent Head with more than 1,000 men, women and children living in them. Brick workers were based in Sebastopol – named after the Crimean War siege of 1855 – with Inkerman, Jericho, Jerusalem and Belgravia nearby. The work was tough and dangerous. Pollution and violence were characteristic of the existence and in 1871 a smallpox epidemic saw more than 200 people die, including women and children. Therefore, it was no surprise that fights broke out regularly and – coupled with the harsh working environment and dangerous conditions – these were fuelled by the number of pubs on site too.

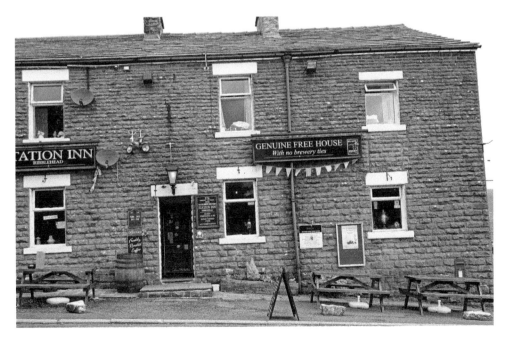

A pub with some great heritage.

The route's construction was ordered by Parliament after a Midland Railway petition. In the 1860s, the East and West Coast main lines linked England and Scotland. The Midland Railway had to negotiate terms with their main operating rivals if they wanted to move freight or people beyond their boundaries. That never was as successful as it should have been so the firm looked at building a route from Settle to Carlisle that avoided the use of other companies. After agreeing a proposed line, the company lobbied Parliament for permission to build it, with success. But no sooner was that granted that relations with rival rail companies improved for the better. Midland asked for the decision to be reversed but that was rejected.

With no going back, construction began in 1869 and was completed in seven years with around 6,000 men working across the 73-mile route. The line was opened to passengers on 1 May 1876 with freight being carried for the first time roughly a year previous. In 1968, the service became entirely diesel-operated but all local stations – apart from Settle and Appleby – closed in 1970. Eleven years later, recommendations were made to close the route to passengers mainly because of the sheer cost of weatherproofing Ribblehead Viaduct. British Rail even looked at keeping the route open and spoke about creating new bridges. Eventually they relented and made the structure safe. A project manager was then appointed by BR to close the line but instead he encouraged passengers to use it more and local stations reopened in 1986. Three years later, the government backed this approach and trains still operate on it today.

The landscape around Ribblehead is filled with the legacy of its construction and The Station Inn is part of that. When building began at Ribblehead in 1869, materials for the major architectural projects of the viaduct and Blea Moor Tunnel were manufactured locally and brought on to the site via small steam locomotives on a small tramway. The stone would be transferred from Ingleton via horse. The viaduct's foundations were sunk some 7.5 metres down into the peat and clay, and were laid by steam cranes. On the site you can see the feint outline of the Batty Green construction camp. Here there were offices and shops, a small town of wooden shacks which were removed when the project was completed. Near the car park, where a tea wagon is often parked is a grassy bit that housed a smallpox hospital. Closer to the viaduct was a locomotive maintenance shed and an inspection pit so mechanics could get underneath the locos. The Porter & Co. of Carlisle brickworks are just a little further along the tramway, and at the height of construction around 20,000 bricks a day were being produced there.

Materials would have been housed where the pub is now, so it seems safe to suggest that the pub only became such in the late 1800s. But it certainly served the growing number of travellers stopping at Ribblehead and is as popular today. On the outside there's a stone that tells the weather (you'll have to take my word for it or see it for yourself) and inside is a large room on the left that is perfect for groups of walkers and visitors. The main dining area is to the right, while in the middle, as it should be, is the bar.

The Station serves great beer and although Black Sheep features on its signs, it is a free house. But it also has local ales including those from Dent Brewery. Another great feature for walkers is train timetables on the chalkboard above the bar on the right-hand side. Very useful. And there's a black Labrador who brings its own food out when it is time for his tea!

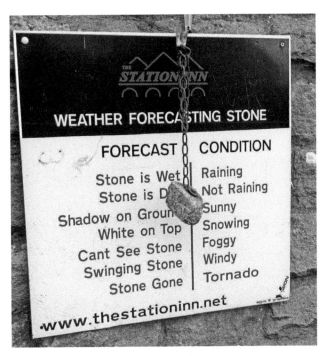

And the weather is...

Functional sitting area.

A great bar with plenty of quirks.

The Pub

Address: The Station Inn, Ribblehead Viaduct, Ingleton, LA6 3AS.
Website: www.thestationinn.net

The Walk

Start Point: The Station Inn (park responsibly).
Destination: Whernside Circular.
Distance: 8 miles.
The Route: Leave the pub, check the weather stone to make sure you have the right gear on, and head left. Take the obvious path on your left, past Batty Wife Cave and towards the viaduct. Instead of going under the viaduct, check left on the obvious path; this takes you to Blea Moor signal box and eventually to Blea Moor tunnel. The path goes left here, so follow it, and it climbs, past Force Gill Waterfall on your left, before it continues to climb. This is part of the Dales High Way. Eventually, after some more climbing, you'll see a stile on your left (SD757824). This takes you to Whernside via a well-slabbed path to its ridge. After visiting the summit cairn, follow the obvious path off the hill which will take you to a crossroad of paths. Go left, through to Ivescar (SD747797), where you will turn right to head to Gunnerfleet Farm. The farm track then goes under Ribblehead Viaduct and home.

23. The Old Hill Inn, Chapel-le-Dale

I always think it is testament to the quality of a pub if its managers or owners are prepared to serve a dirty, miserable walker who just stumbles off the fell even when they aren't technically open. One day in the Dales, after some impromptu caving followed by a good soaking, I happened on The Old Hill Inn at Chapel-le-Dale and chanced the door to see if it was open. It creaked as I made my entrance and I was hit by the warmness in the porch and then the glow of the bar through another door on the right. A lady appeared and asked me if I wanted a drink. I obviously did, and plumped for a pint of Dent and a bench near the fire. It was late afternoon and something told me I wasn't really supposed to be in there pre-opening.

Sabena Martin, the landlady, told me they had a few guests upstairs and she was preparing for evening meals. She then disappeared and asked me to pop round the other side of the pub if I needed a refill. I had the bar all to myself, listening to the rattle of the rain on the windows and a stiff wind blowing off Ingleborough. The pub creaked in the right places, felt homely and seemed happy to have me.

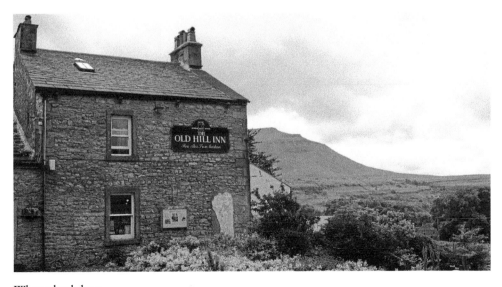

What a backdrop.

It's fair to say The Old Hill Inn is a place of real character. It dates back to 1615 in places with a newer 'section' built around 1835. It was originally a farm, which is understandable considering its remote location and the fact it isn't really near any areas of habitation. It then became a drover's inn and now welcomes travellers from all over the world. In fact, of all the pubs I visited in the Dales this felt like the oldest, even though it is the second oldest in the book behind The Angel in Hetton, or the third if you count the Red Lion and its twelfth-century cellars. It is well used and tells a story: Winston Churchill used it as a base for his hunting, shooting and fishing holidays.

Speaking of tales, the pub sparked the Three Peaks walk and thus the challenge we have today. In July 1887, Canon J. R. Wynne-Edwards and D. R. Smith, both masters at Giggleswick School, climbed the 2,373 feet of Ingleborough and then decided to stop in the Hill Inn for a refreshing drink. From there the strong brew galvanised them and they set upon the idea of walking off along Bruntscar and then up Whernside before continuing to Pen-y-Ghent. The ascent of the Three Peaks – the first recorded Three Peaks walk – took them around eight hours in total and no doubt led to blisters and a sense of achievement. Who would have thought that trip would have led to the

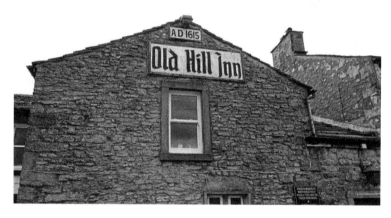

1615 – one of the oldest in the Dales.

Stone features throughout.

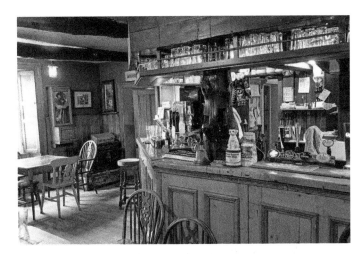

A cracker!

The intricacies of Colin's
sugar sculptures.

Three Peaks Challenge today where people aim to cover 25 miles, and climb all three peaks, from Horton-in-Ribblesdale.

Back in the Hill Inn, Sabena invited me in the dining area of the pub to see some of the other things they had on display. She told me she always wanted to provide fine food and running a pub wasn't probably in her mind years ago, but she wouldn't change a thing. Husband Colin is a famous pastry chef and sculpts sugar. Several of his sculptures are on display and they are absolutely phenomenal. The intricacies of his work and the detail of the figures, all in sugar, shouldn't be missed. Yes, they are housed in one of the oldest pubs in the Dale, and yes some people might think they look out of place but to me, they were out of this world.

Colin runs a School of Sugar from his studio at The Hill Inn too, and people are invited to go on one of his courses. His experience stretches thirty years and he has sculpted for some of the world's leading kitchens and royal houses. A fascinating addition to a fascinating pub.

The Pub

Address: The Old Hill Inn, Chapel-le-Dale, Ingleton, North Yorkshire, LA6 3AR.
Website: www.oldhillinn.co.uk

The Walk

Start Point: The lay-by on the road up from The Old Hill Inn.
Destination: Great Douk and Southerscales.
Distance: 2 miles ... or more if you want to head up to Ingleborough.
The Route: From the lay-by, head down the road until you walk past the water monitoring building. Take the obvious path on the left through Philpin Sleights. Take this path and you will reach a gate, go through it (close it behind you!) and turn left to head up to Great Douk Cave (SD747770). Scramble down into its depths – nothing strenuous or dangerous here, just take your time. On your left is a pothole that was dug out by cavers trying to find where the water goes. Further on up you'll see the waterfall emerging from the cave. It is possible to climb up this waterfall and enter the cave, alternatively there is a ridge route further back on the right-hand side which leads to a higher level crawl. Inside, go right and you're able to explore some of its magnificent features. Once you're wet through, head back out of the cave and retrace your steps. Halfway down turn left and Southerscales is on your left. A magnificent gem. The route can be followed past Southerscales and onwards, up to High Lot and on to Ingleborough.

24. The Wheatsheaf, Ingleton

First up, a confession: this is one of my favourite pubs from all of my journeys around the Dales. It isn't the most glamorous, but in terms of great beer and a great place to meet people after a long day above and below fell, I don't think there is any better.

Ingleton has always been a destination of mine whenever I am in the Dales. It's a regular pilgrimage which comes from my younger days when a trip up the M6 could have brought a good look around the caving shops and the possibility of going underground. For that alone, caving cafés Inglesport (best flapjack in the world) and Bernie's are must visits. But recently that focus has moved to The Wheatsheaf, in the main due to Johnny Hartnell who works in Inglesport. The adventures out on the hills and down deep and often horrible caves inevitably mean we head to the end of the village and have a beer.

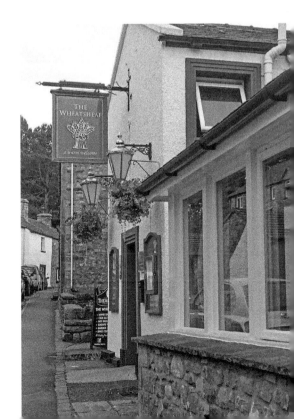

The Wheatsheaf – hub of many an adventure.

The Wheatsheaf has history stretching back to the seventeenth century. It was originally a coaching in which was extended in the 1800s to include a blacksmith's shop and stables to help service the number of travellers coming past the inn. That is now used as the pub's dining room. One of the rooms upstairs was used as a court house to the Ewercross district. JPs met to renew the licenses for many of the inns in the area.

The pub emphasises its old features with upright wooden beams marking the bar area and where the pool table is. The bar itself is massive and well stocked, with seating down one side of the wall making that serving area almost a stage. Well known drinking sayings adorn the walls too such as 'I feel sorry for people who don't drink. When they wake up in the morning that's as good as they're going to feel all day' and, 'In wine there is wisdom, in beer there is freedom in water there is bacteria.'

The tales and stories in the Wheaty are well worth a listen and not all caving orientated like those of The New Inn in Clapham, or the old New Inn before it was made the new New Inn ... if that makes sense. Johnny tells one story which involves the pub and an incident that could have been quite serious:

I was drinking in there after hours and Tony and Maria Holt, the landlord and landlady, asked me if I would close the curtains by the door up near the pool table. I had to stand on a chair to lean over to close them. All of a sudden there was glass everywhere ... and I mean everywhere ... and everybody presumed I had knocked a glass off the table in a drunken state.

Upright beams.

Suddenly, they realised the window was missing in the pub ... I say missing, it was on the floor in bits. It turns out somebody from the outside had fired a handful of steel ball bearings maybe with a black widow style catapult through the window. Some of which had embedded themselves in the upright beams! At first we thought they had fired a gun through the window. A couple of drinkers in the pub gave chase but lost the youth ... I had my lucky pants on that night but got free whisky to straighten me up from the landlord!

After leaving the Wheaty it is worth heading down the road, back into the village, to visit the Old Post Office. Matt and Fiona Barrett have transformed this former hub of Ingleton life into a small and trendy bar which serves a great choice of whiskies, gins and bottled beers. It also has some tremendous food platters too and while they are hard pushed to get more than, say, twenty in there, it is cosy and not to be missed.

The Pub

Address: The Wheatsheaf, 22 High Street, Ingleton, LA6 3AD.
Website: www.thewheatsheaf-ingleton.co.uk

The Walk

Start Point: Ingleton Community Centre Car Park.
Destination: Ingleborough.
Distance: 3.5 miles.
The Route: Come out of the car park near the viaduct and head into, up and out of the village passing the 'Wheaty' on your right. Go left and up the hill and before the road goes left, you'll notice an obvious stone path in the corner (SD701731). Join it, it's hard work but Fell Lane takes you to Crina Bottom which is just magnificent. Continue on this route and you'll reach the cairn of Ingleborough. Retrace your steps and return to Ingleton.

25. Barbon Inn, Barbon

Barbon won't be technically part of the Yorkshire Dales until at least August, but we'll allow a little licence on this occasion for one of most tranquil areas of the soon-to-be extended National Park.

On the west side of the Dale, only a few miles before the Park's boundary, it is the ideal walkers' paradise with the oft ignored Calf Top the perfect wander.

Although it is only 3 miles north of Kirkby Lonsdale, Barbon itself is off the beaten track, set back from the A683, and therefore a very quiet and peaceful place to while away the hours. There are around 250 people who live there and the Barbon Inn is impossible to miss. Heading into the village, as the road climbs, it is on your right. It is a traditional seventeenth-century coaching inn with plenty of character. It began life as a farmhouse in the Lune Valley in the 1650s and those buildings are evident on the right-hand side before you enter the pub.

The bar area is small but perfectly in keeping with a pub of this age. It had an autumnal feel when I visited with what looked like wheat fixed above the serving area. Sisters Sandra Grainger and Joyce Mason decided to open up the fireplaces a couple of years back and that has made a massive difference to the overall feel of the place – it's snug and comfortable. Through a small doorway on the right, near the bar, is another smaller room and to the left of that is a larger dining area.

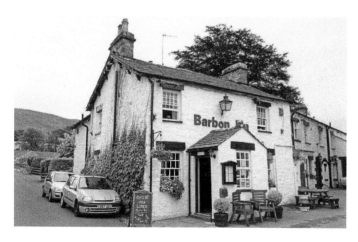

A former farmhouse.

But it's in the bar you really understand what it would have been like to be in this pub 300 years ago. It's tight, even somewhat cramped, but buzzing in the evenings as locals come in and meet. Local ales also help with the atmosphere and the inn has ten rooms if you don't fancy driving!

The bar nods to its country heritage.

Now this is a snug!

The Pub

Address: The Barbon Inn & Restaurant, Barbon, Nr Kirkby Lonsdale, Cumbria, LA6 2LJ.
Website: www.barbon-inn.co.uk

The Walk

Start Point: Barbon Church.
Destination: Calf Top.
Distance: 3.5 miles (linear).
The Route: With St Bartholomew on your left, turn left just after and follow the road to a bend. Take the path on your left which heads around the outside of Ellers Wood to Eskholme. Here, you have three different ways to choose, you need to pass through a gate and take the path that goes right up the hill and on to access land. Follow this route, sketchy in places, past the cairn on Eskholme Pike (around SD640833). Continue on this path to the summit of Castle Knott. From here, continue onwards, dropping a little height, before ascending once again to the trig point on Calf Top (SD664856). Soon, the land in Barbondale will be part of the National Park.

Acknowledgements

I'd like to thank all of the landlords and staff who made me feel very welcome. Every single one went out of their way to make sure I was fed and watered. Particular gratitude has to go to Ed Yarrow and his wife Jackie at The George Inn at Hubberholme for the guided tour; the staff and team at the Devonshire in Grassington; the great folk at the 'Wheaty' in Ingleton; Pascal at The Angel Inn in Hetton; The Fountaine Inn; Patrick Chaplin of the Pub History Society for his great article on The New Inn in Appletreewick; and finally, Viv and Steve for surely the most fantastic night of my walking and bivvying life at The Tan Hill Inn.

Johnny Hartnell from Ingleton deserves credit as well, for not only attending many of these pubs and walks alongside the author but also for continuing to champion the project even after he suffered a serious damaged wrist in a spectacular and somewhat comedic plummet to the ground at Kisdon Falls.

As ever, Nigel McFarlane has lent his invaluable proofing skills. He is a true friend and amazing support during my projects.

I hope the reader has enjoyed the pubs, the beer, the camaraderie and the walks.

About the Author

Mike Appleton has been a journalist, editor, author and media professional since 1998. He has received critical acclaim for his publications. Born in St Helens, but now living in Leigh in Lancashire, he made regular trips to the Yorkshire Dales with his father and those early days bore an obsession with the area and its people and resulted in his books *Yorkshire's Three Peaks: The Inside Story of the Dales* and *50 Gems of the Yorkshire Dales*. He is an active caver and walker and spends as much time as he can in the Yorkshire Dales, writing and photographing this unique landscape.